DECORATIVE ALPHABETS AND INITIALS

Edited by Alexander Nesbitt

Dover Publications, Inc. New York

Published in Canada by General Publishing Com-
pany, Ltd., 30 Lesmill Road, Don Mills, Toronto,
Ontario.
Published in the United Kingdom by Constable
and Company, Ltd., 10 Orange Street, London
WC 2.

Decorative Alphabets and Initials is a new work
published, for the first time by Dover Publications,
Inc., in 1959.

International Standard Book Number: 0-486-20544-4
Library of Congress Catalog Card Number: 59-65116

Manufactured in the United States of America
Dover Publications, Inc.
180 Varick Street
New York, N. Y. 10014

Foreword

This book had its beginning in a collection of books and portfolios made by Mr. Hayward Cirker. All of this material was long out of print, obtainable only in libraries or, now and then, in the second-hand, rare-book market. Mr. Cirker felt, justifiably, that if the best of the pages, the sets of alphabets and examples of ornamented letters, could be put together in a book it would make an interesting and useful source for designers and students. He asked me to make a selection of pages; to put them into chronological, historical sequence if you will; and to add whatever notes seemed advisable to make such a reference book.

The pages that I have chosen cover the entire range of the history of the initial letter. There are some gaps to be sure; but this is unavoidable if one is to end with a handy and workable book. Actually, the subject of initials and ornamented letters could not be encompassed in a score of volumes; and it is for this reason that there is no book that attempts any great coverage of their entire history.

There are books, beautiful and costly, that make a careful study of a single phase of initials: those contained in just one manuscript, the Folchart Psalter for instance; or the production of just one cloister; or, it may be, the work of one historical period. The average artist or designer is not too apt to have access to them. But some of these books will be noted in the bibliography, for the benefit of those who wish to pursue the fanciful initial further. The source of each of the pages in this present collection has also been recorded there.

The book itself has been divided into three parts, each with a few pages of explanation preceding the illustrations. In these short essays and the one-line page captions the reader will be given the basic information that seems pertinent for his understanding of the various alphabets and styles. Part I will deal with manuscript initials, as they were used from the 8th, to the 15th century. Part II will explain some of the development, stylistically and technically, of the printed initial from the start of printing in the second half of the 15th century through the 18th. The final section takes in the peculiar 19th century manifestation: the great, weedy jungle of Victorian ornamented letters; and brings us up to the present.

What started as a mere matter of selection has, the reader will no doubt note, turned into a considerable study of the ornamented letter. I believe Mr. Cirker's original idea of putting this mostly forgotten material back into print was a sound one. If I have improved the matter any by my choice of pages and the notes — so that the book is thereby more useful to the general public — I shall be pleased.

Providence, Rhode Island Alexander Nesbitt
February 6, 1958

Table of Contents

Part I Manuscript initials, 8th century to the 15th.

For a thousand years, more or less, a great measure of Western man's desire to ornament and embellish was expended upon the initial letter. There are various reasons for this; and these may, with some profit, be examined briefly. All writing in its early history was a sacred and mysterious form of expression. It was not by chance, therefore, that the early monastic scribes began to devote an entire page to a letter surrounded by, or set into, exquisite ornamentation — the letter was the symbol for the godhead, the saint, or the divine word; and was adorned just as carefully as the altar itself. Obviously a great act of devotion was performed in the planning and execution of such letters or pages; but just as fundamental as the new religion was the new field in which man's age-old love for ornament could be exercised. This field was the devotional manuscript book; and it was in such books that the fanciful initial had its greatest, its most complete development.

The Roman manuscript book of pre-Christian times had undoubtedly often been illustrated and ornamented. Not many of these books survived the collapse of the empire, however. One may start the study of ornamented initials in the surviving pages of a 4th century Virgil, which seems to represent a high point in Roman manuscript production, after its change from the volumen to the codex in the 2nd and 3rd centuries. On the page I have in mind there is a stickup initial beginning a passage. It is a relatively modest letter, done in pen outline, with the zigzag ornament given some touches of color. Such initials, which indicate the degree of importance attached

to their use in Roman times, are far removed indeed from the sets of ornamented letters that one may study in the psalters, evangels, and other devotional books produced by the Christian cloisters and monasteries, after the conversion of much of Western Europe to this religion and method of worship.

We must seek elsewhere than in the classic manuscripts of Rome for the real beginning of the ornamented letter as we know it, — as it was developed in the Western European art of the book. It was almost entirely a Celto-Germanic creation. Not that there were no Roman or Byzantine influences discernible in the first productions of the Western scribes; but the character of the scribes themselves is what is projected so clearly from their pages. This character, in contrast to that of the earlier classic world of Rome, was a dynamic and wilful one. Certainly the Celtic spiral motif represented it well. It was based on a mystical interpretation of the universe as a place of unceasing battle, of constant struggle. That the art of these Celtic and Germanic scribes expressed the feeling of ever-expanding, ever-increasing force and energy was not accidental. Actually, the Celt was never subdued: his own ebullience and flaming zeal finally defeated itself. He established a direction, and others had to carry the work further. These others were the Germanic partners, who were not unlike the Celts in their nature and character — it remained for them to achieve a kind of balance between Roman order and the Celto-Germanic dynamism.

The Celts long preceded the Germans in their conquest of Western Europe. Their spiraling sweep from the east had carried them through the areas of Southern Germany, France, Spain, Italy and Asia Minor long before the Christian era. In Ireland they became zealous adherents of Christianity; and, when the course of physical conquest had run itself out, and Celtic power was everywhere lost, Irish monks set out as missionaries to the mainland of Europe and once again conquered it. They brought with them the art of the book as it is exemplified in the great Book of Kells; they founded the earliest of the cloisters in which this new art had its beginnings on the continent. That their dominant position in these institutions was soon taken over by Anglo-Saxon and German monks does not lessen the importance of the tremendous first effort that established the traditional cloisters, with their writing rooms, scribes, and artists of all kinds.

The direction of development may be followed very simply; although it is possible to delve as deeply as one wishes in tracing the various influences and schools. Starting with the Book of Kells, which was produced in Ireland, one may follow the Irish influence to England and then to the continent. The Irish had a large share in converting the Anglo-Saxons to Christianity, and imparted to them an interest in producing superb manuscripts containing magnificently wrought initial letters. The Book of Kells is generally dated at the beginning of the 8th century. Students may find reproductions of its pages in a facsimile edition produced by the Urs Graf Verlag of Switzerland in 1950, or in Sir Edward Sullivan's, *The Book of Kells,* published in 1933. The initials or monograms in Kells are possibly the most fantastic and complicated that have ever been created — they portray all the boundless fury of the Celtic spirit. One may study the use of outlining dots, spirals, braidwork, zoomorphic de-

signs, some plant forms and figure representation — all the symbols and motifs that the once-pagan Celts had carried over into their expression of personal faith, their devotion to the new God.

The next step for the reader would be to see the initials in the Lindisfarne Gospels. This is a book that some believe rivals Kells; quite recently it was also reproduced in facsimile by the Urs Graf Verlag. Lindisfarne was a cloister on a small island, Holy Island, off the coast of Northumberland. It was here that Celtic Christianity was first established in England; and it is quite certain that the founding Irish fathers brought the pattern and spirit of the wonderful Kells book with them. There is visual evidence, though, of a greater feeling for the page — the designs do not tend to explode in all directions. Apparently the scribe, Bishop Eadfrith, began to consider the architecture of the page. From this point, which may be contemporary with Kells, we may jump to the famous second Bible of Charles the Bald — represented by the second group of initials illustrated in this book.

There are definite reasons for not trying to show much of the Kells or Lindisfarne initials in the present work, which is simply concerned with giving the student or reader a fairly good, over-all understanding of the history and use of initial letters, especially the decorated or ornamental variety. Since most of the initials of the 8th and 9th centuries were in quite full color, upon which they rely very much for their effect, it would be foolish to show much more than line patterns in a one-color book such as this. Line renderings of Kells or Lindisfarne designs yield little; and, in my estimation, a halftone would be worse. A few line patterns of the simpler Irish initials are shown to make this clear — the rich, bewildering monogrammatic opening pages of the gospels are not reproducible in line. These examples are mostly from Kells; the Lindisfarne book presents a similar problem.

The Charles the Bald initials that begin the book are also merely line patterns. Although they cannot give the rich effect of the gold and color, they are sufficiently clear to show the intricacy of design and the relationship to the insular style of Kells and Lindisfarne. All the heavy black strokes and heavy braidwork finials are in gold; the outlining dots are red, as they were generally; the more delicate interlacing is white as it appears; the shading indicates various colors, mostly yellows, greens and blues. Gold was also used for the large Roman capitals that give the title of the book of the Bible. For special writing liquid gold was sometimes used; but the gold of these initials, monograms and ciphers was applied in leaf form over a raised base; then it was burnished until it shone brilliantly. This was quite a different effect from Kells, in which no gold was used, or the Lindisfarne Gospels where little was applied.

This Bible of Charles the Bald was finished sometime after 865, somewhere in the present area of northern France, or Belgium. It is characteristic, in its decoration, of a group of scribes and illuminators known as the Franco-Saxon school; their exact place of activity has not been established. Perhaps the name isn't quite the correct one, but it does make clear that there was a combining of Frankish and Irish-Saxon influences — in other words, the Germanic and Celtic ways of doing things. To this was

added a renewed interest in the Roman capital letter, and the order and symmetry of Roman design. One should note the heads of dogs and birds, and the reptilian designs. These features are carried through the Carlovingian and Romanesque periods into the area of Gothic art — by which time the initial had become simply a decorative element on the page, no longer a visual expression of the Word of God.

In the succeeding illustrations of initials in this section some of the changes and developments up to the time of the printed book will be shown. It has been said that the history of the initial as it was used at the cloister of St. Gall is typical of the general history from the 8th century to the 12th. St. Gall was founded by Gallus, who had accompanied Columban to Europe from Ireland. At first the work of its scriptorium was essentially Irish; but, since it lay in the Alemannic area, its control gradually fell more and more into the hands of the Germanic element. Though its manuscript production retained a Celtic character a generation longer than the West Frankish cloisters, it finally adopted the use of Germanic braid and strapwork based, however, on the classic vine motif. Several of the examples in this section illustrate this pattern quite well. In its severe style the intertwined motif was in gold with touches of silver — the whole placed on a colored background, sometimes of sienna, green or blue. This style reached a high point in the Folchart Psalter and a further development in the Golden Psalter. The center of importance in this region shifted to the neighboring cloister of Reichenau during the Ottonic period, with further changes of style, especially the use of naturalistic flowers and some historiation. This last term simply means that the counter of the letter was used for an illustration; in other words, that the letter was a frame for a picture.

It is possible to perceive from this brief description that the once flourishing art of the initial was languishing. By the time of the Ottonic kings of the Holy Roman Empire the Romanesque style had evolved. Severe Carlovingian style, with its simplicity and classic appearance, was superseded by a much more naturalistic one. The clambering style, articulated letters, inhabited scrolls had all been developed. The initial gradually became subordinate to the illustration; the ability to project the word through the use of what was essentially a non-objective art was lost. By Gothic times the initial was just pretty and nothing else. The gold was taken from the scrolls and used as a solid background, as were other colors; the solid-background initial was a fashion for a time. Charming naturalistic flowers and scenes took the place of severe, abstract motifs. Background techniques were often just senseless doodling. The great art of the manuscript initial was over, unfortunately; and the art of printing was not very far away, when a whole new practice would be launched that would sweep away the final vestiges of the Middle Ages and the manuscript book along with them.

Plate 1. Line renderings of early Irish initials—8th century.

INCPT LIBER NVMR̄I

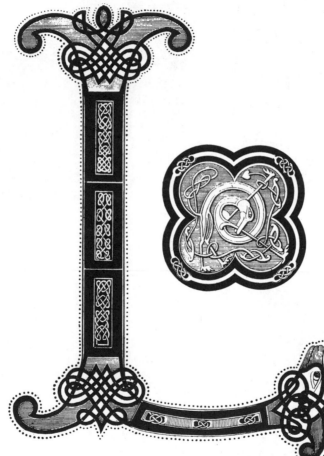

CATUSQUEESIDNS
ADMOYSENINDE
SERTOSYNAIINIA
BERNACULOFOE
DERIS · PRIMADIE

Plate 2. Initials from the second Bible of Charles the Bald—manuscript, after 865, Carlovingian.

EZRAE

NANNOPRI
MOCYRIRE
GISPERSA
RUM UTIM
PLERCTUR
UERBUDNI
EXOREHIERI
MIAE SUSCI
TAUII DNS
SPM CYRIRE
CISPERSARU
ETTRANSDU
XITUOCEIN
UNIUERSO
RECNOSUO
ETIAM PER
SCRIPTURÃ
DICENS

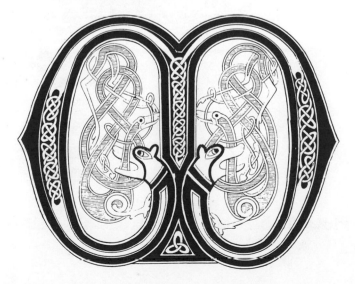

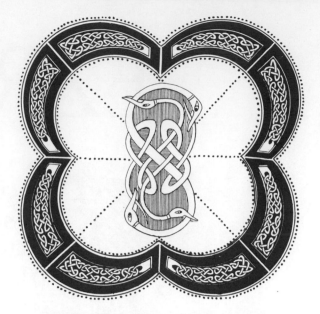

EXLETXA

meosculooris

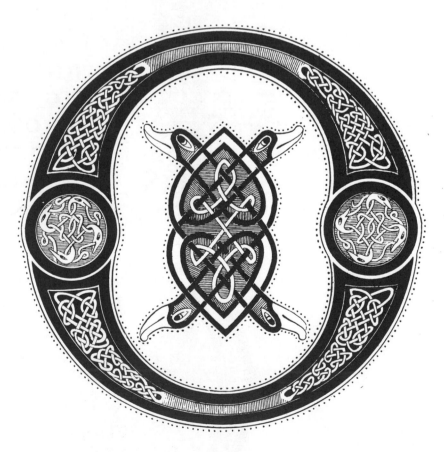

Plate 3. Second Bible of Charles the Bald—written, probably, in the area of northern France.

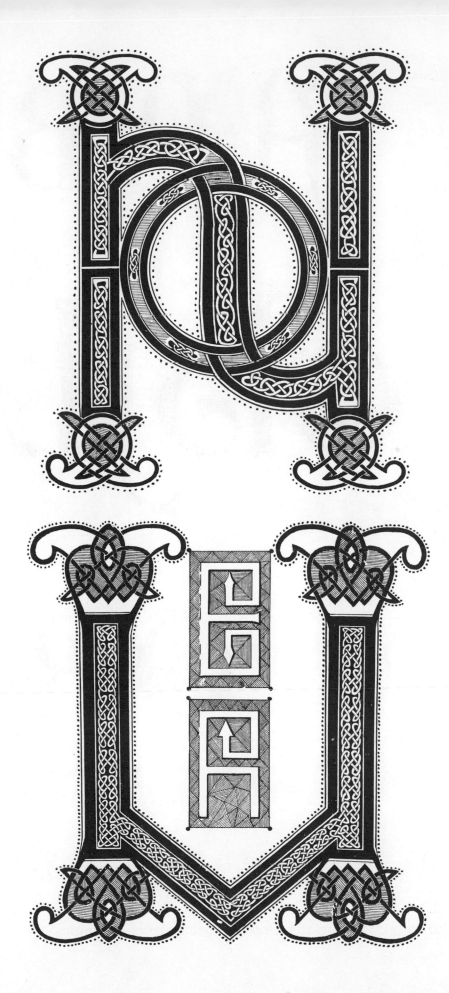

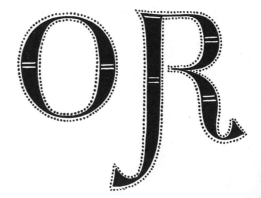

Plate 4. Early Anglo-Saxon initial designs—note characteristic outlining dots.

C C D D E F

M M N H I P

S S S T U

ABCDEFGHIJK
LMNOPQRS
VUXVZ

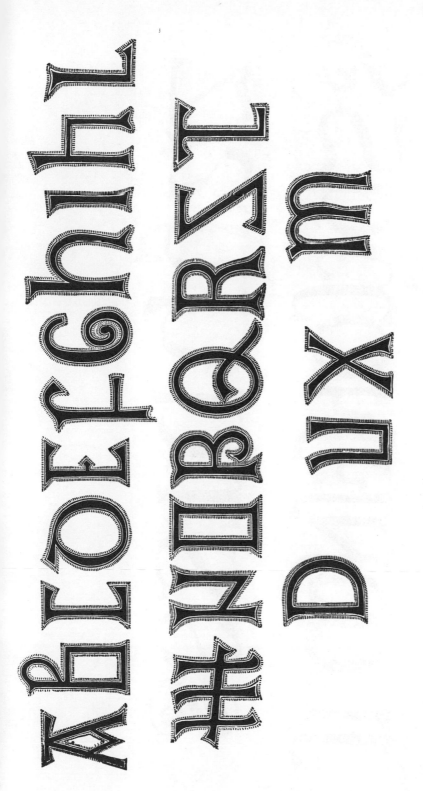

Plate 5. Upper alphabet shows Roman rustica influence; lower, Anglo-Saxon—both 8th century.

AABCCOEFGbh

JLonHhopss

Zzhhnurz

SSsstuss

Plate 6. Anglo-Saxon manuscript initials—upper is 9th century; lower, 10th century.

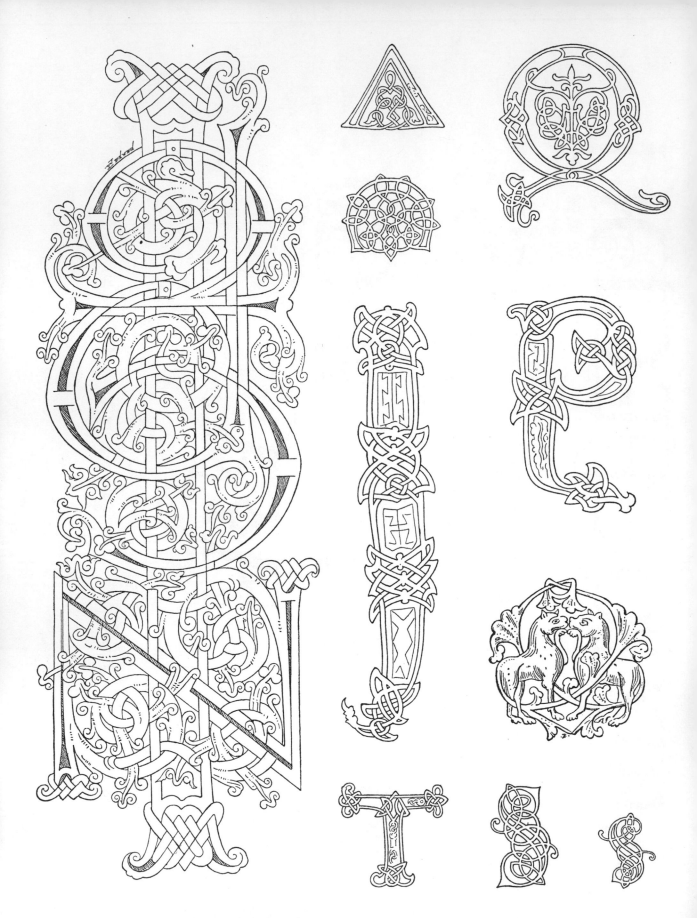

Plate 7. Characteristic designs, 9th to 11th century—interlacing bands were usually gold.

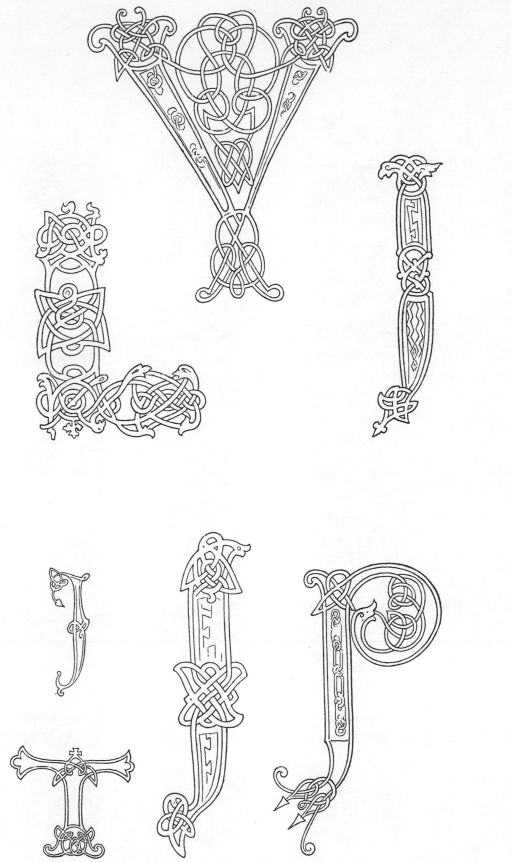

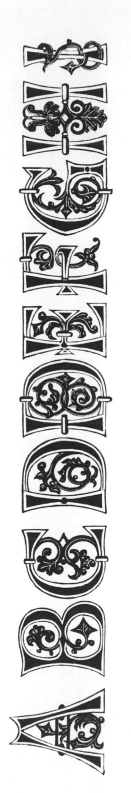

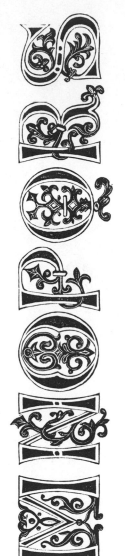

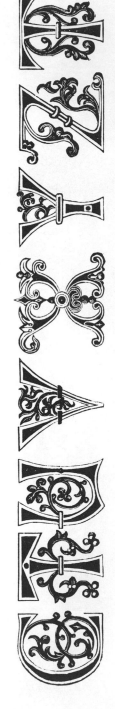

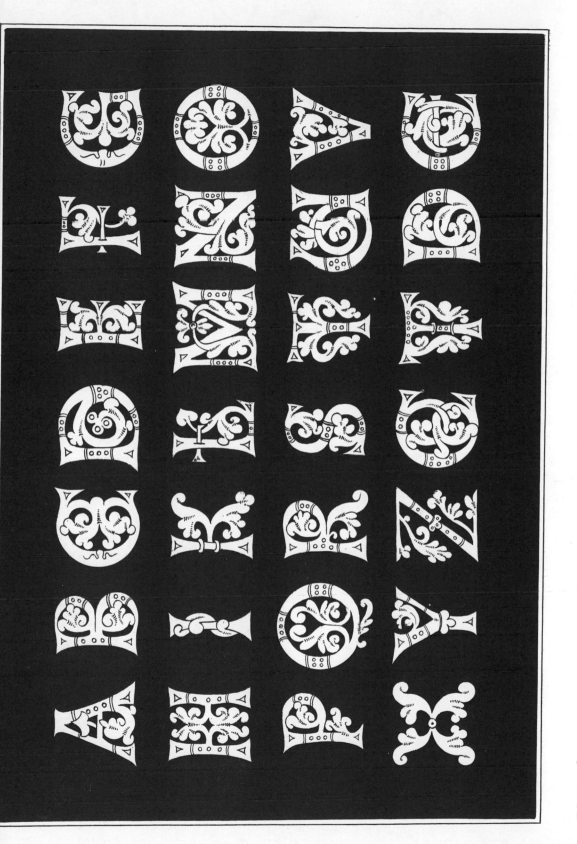

Plate 8. Line patterns of 11th century manuscript initials—foliated ornament was often gold.

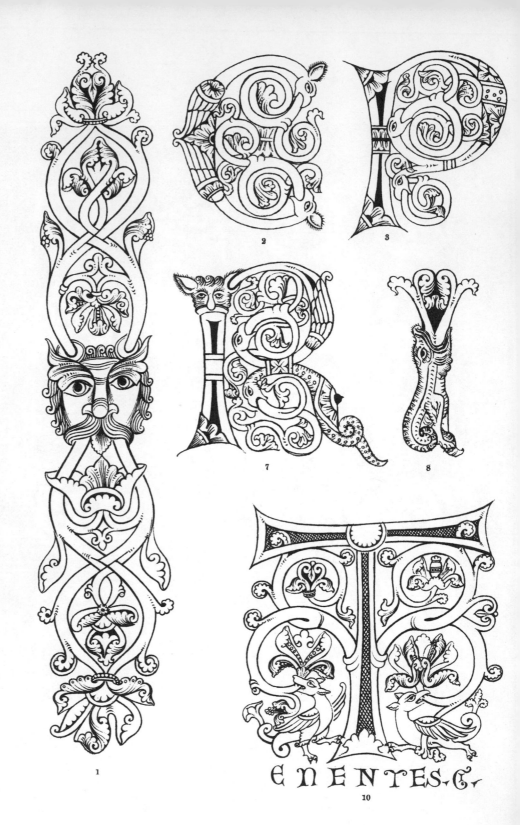

Plate 9. Line initials from 12th century manuscripts—patterns are typical of the period.

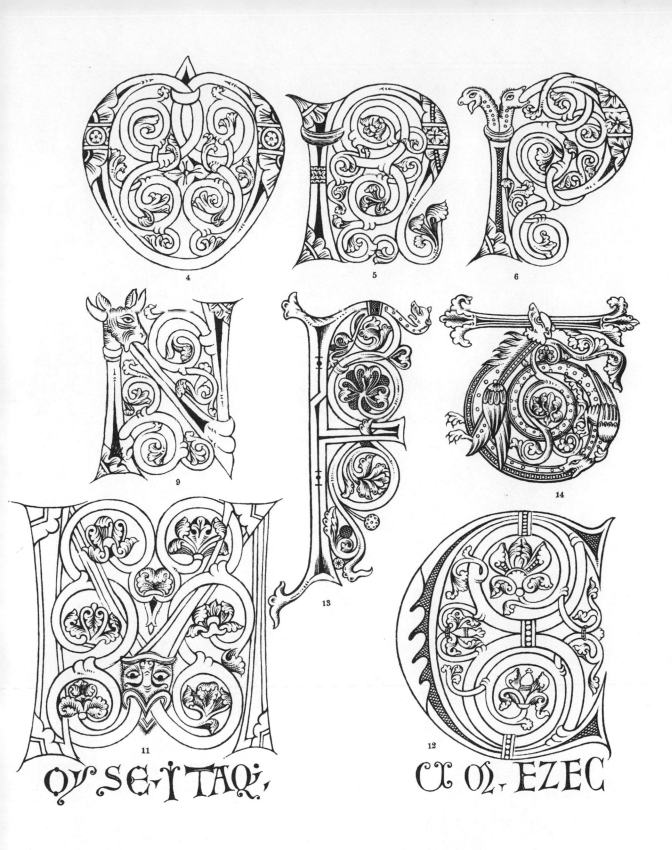

4

5

6

9

13

14

11

12

QVSE·ITAQ.

α Oᒣᴇ EZEC

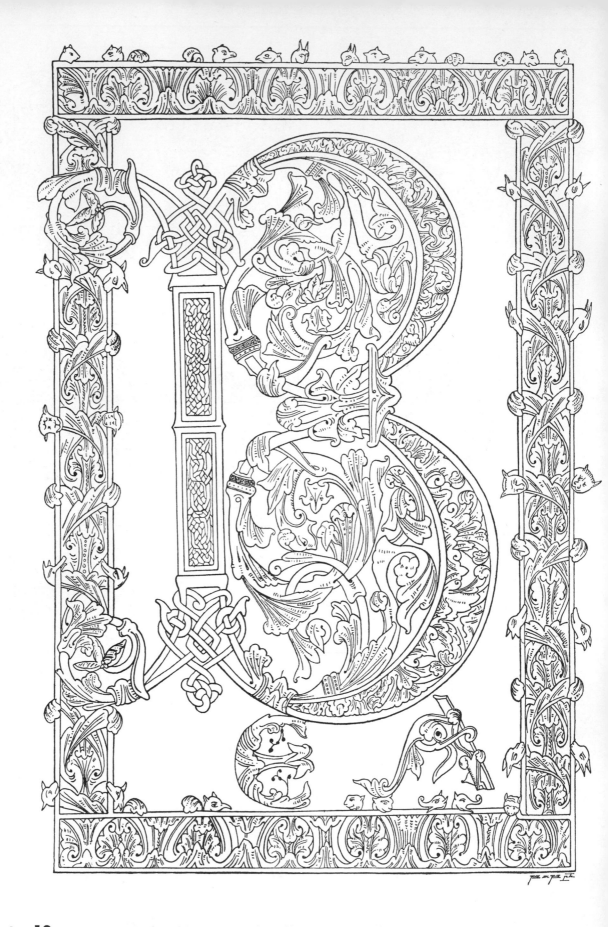

Plate 10. Line renderings of gilded, highly colored 12th century initials, Romanesque.

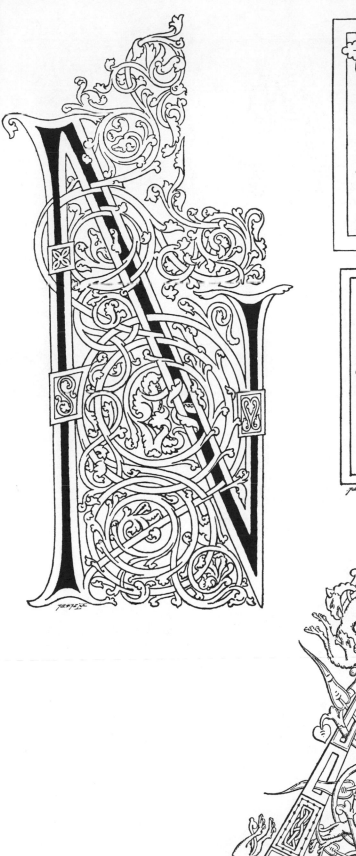
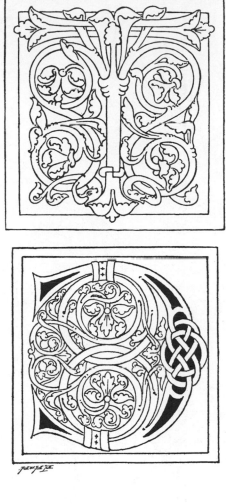
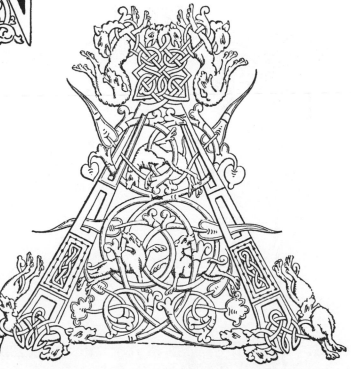

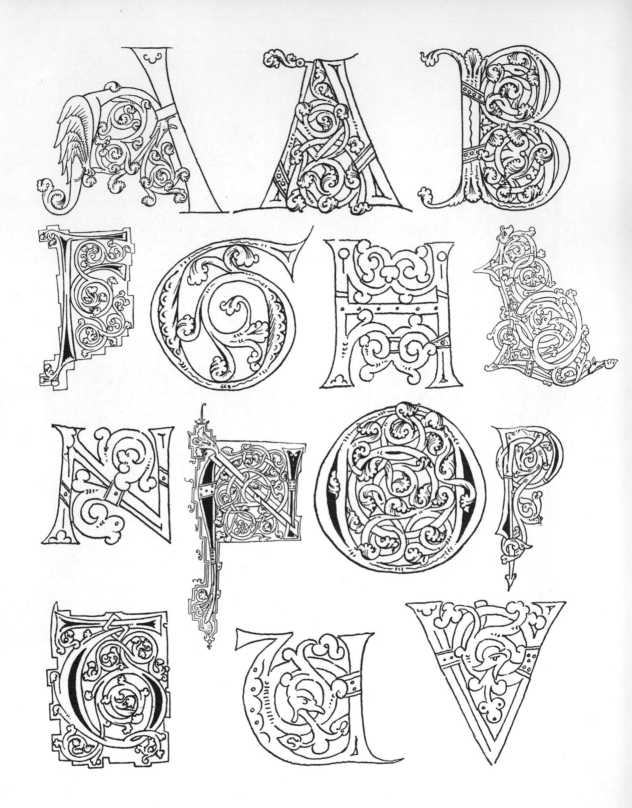

Plate 11. Typical designs of the 11th, 12th, 13th centuries—German and French areas.

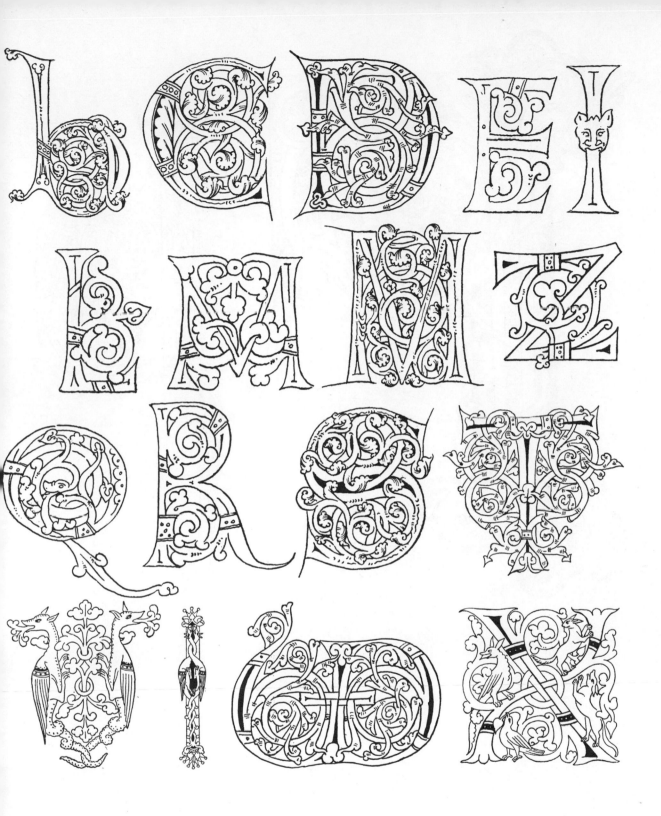

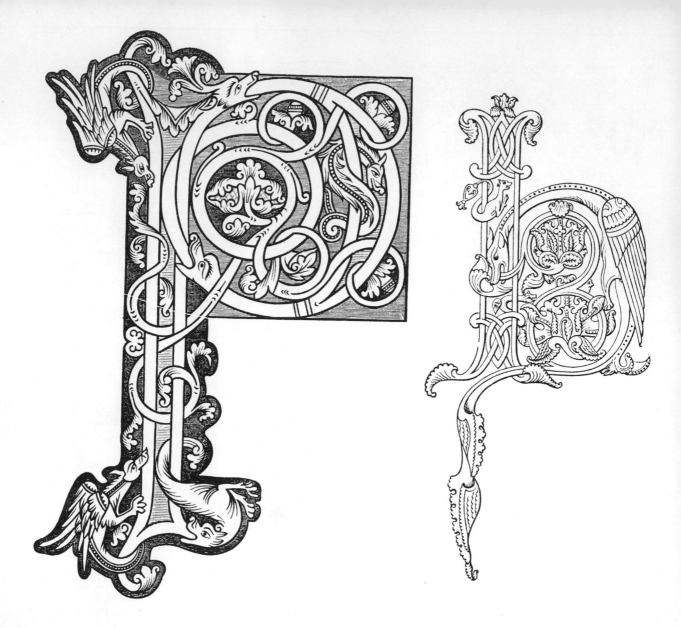

Plate 12. 12th century—H is on gold ground; other letters in various colors.

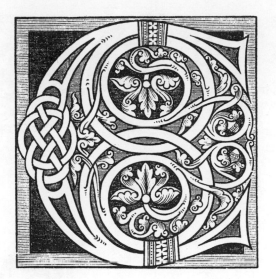

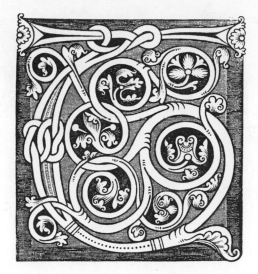

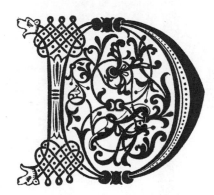

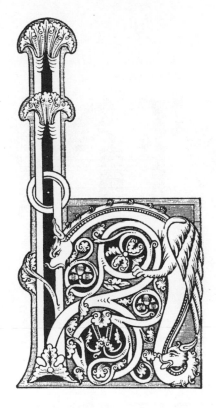

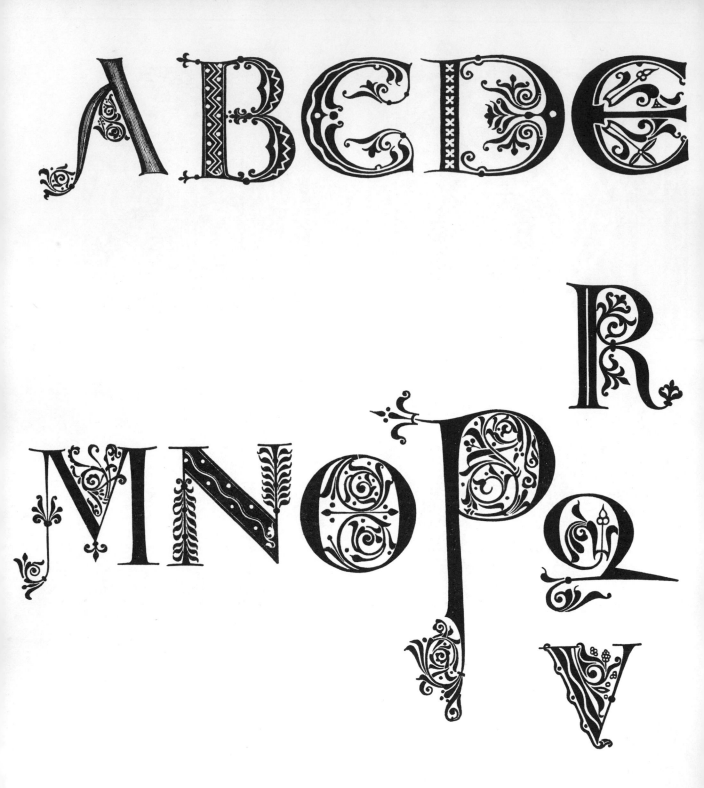

Plate 13. Simple 12th century initials—colors were generally gold, red, blue, green.

ABCDOEEFChIBLM
MNOPQRSTUVXYZ

ABCDEFGHIJK
LMNOPQRST
UVWXYZ

ABCDEFGHI

KLMNOPQRS

TUVWXYZ

Plate 14. Initials from 12th and 13th-century manuscripts, British Museum, early Gothic.

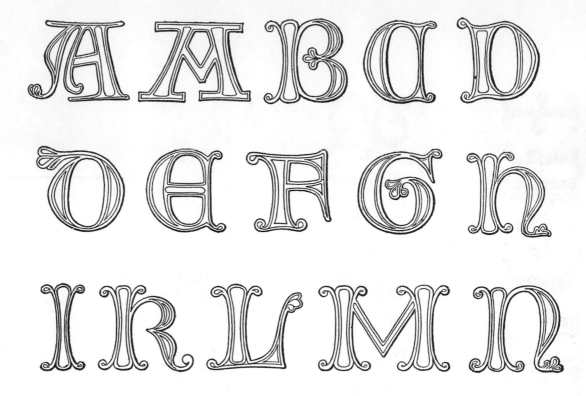

Plate 15. Incised letters from the tomb of Henry III, Westminster Abbey, about 1272.

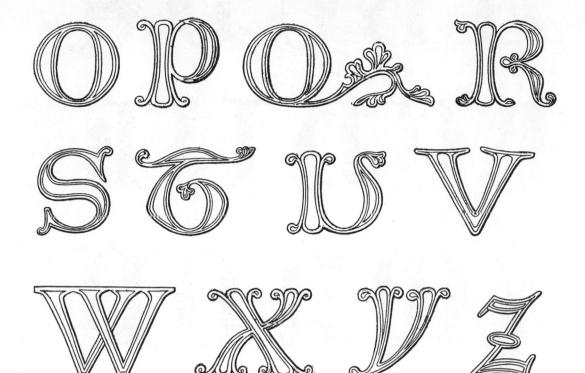

ABCDE

FGHIJK

LMNOP

QRSTV

WXYZ

✦ Anno · Domini ·

Plate 16. Letters in a brass plate, from the cathedral at Lübeck, about 1341.

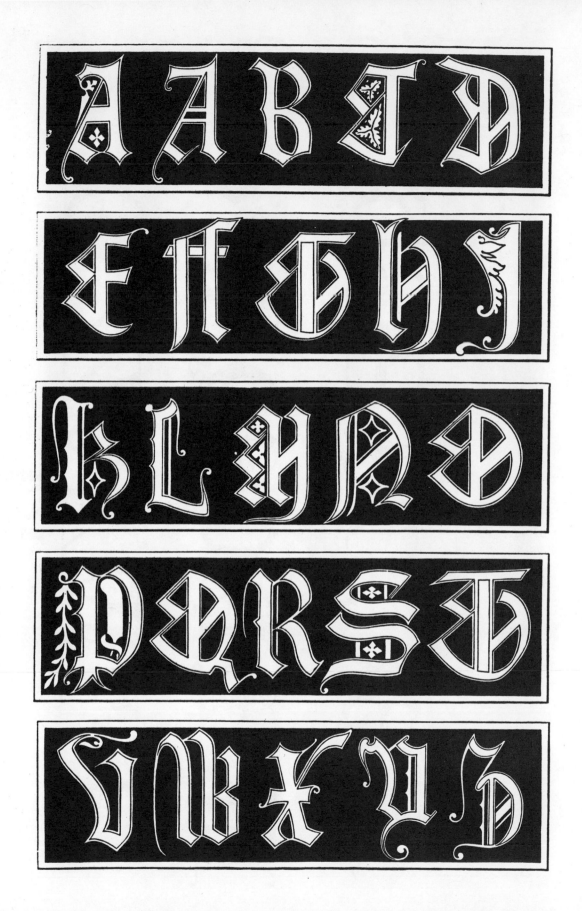

Plate 17. Incised letters from the monument of Richard II, Westminster Abbey, about 1400.

A B C D E F G H I
K L M N O P Q R S T
U V X Y Z

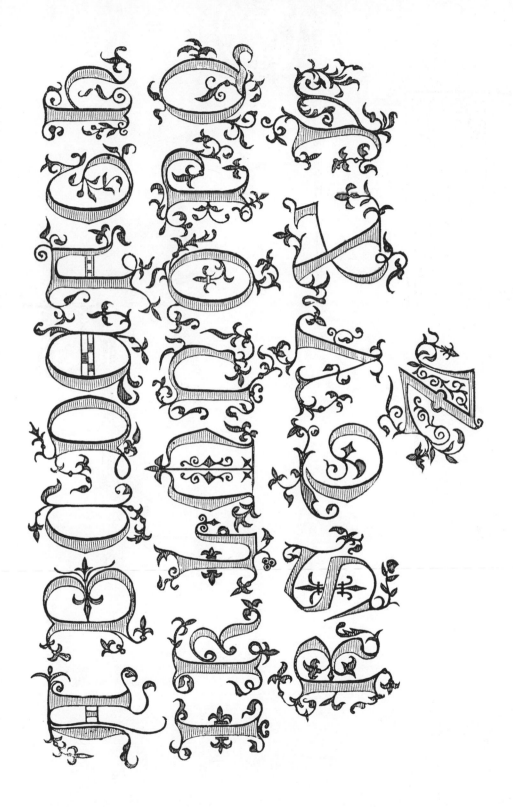

Plate 18. 14th century—upper alphabet is from a manuscript; lower is embroidery.

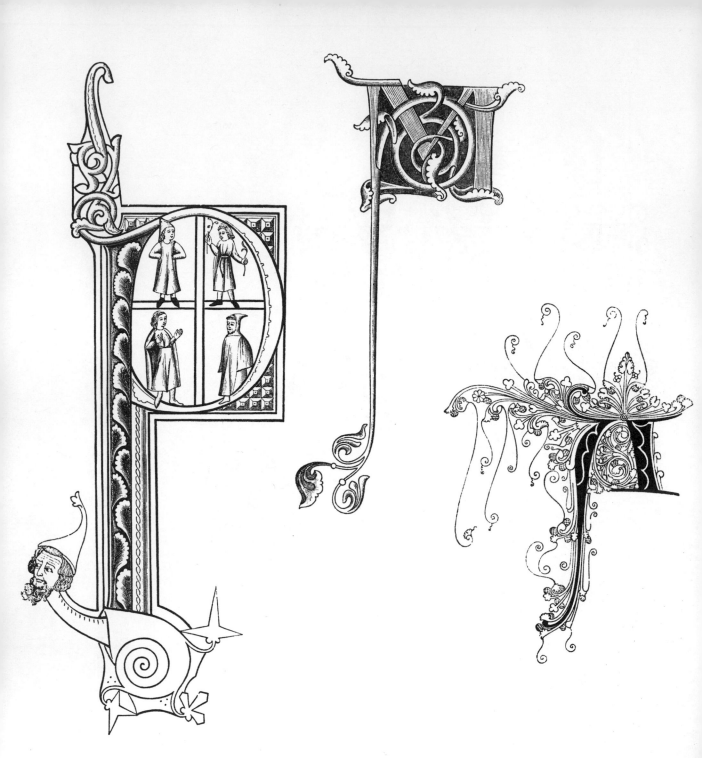

Plate 19. From manuscripts in the British museum, 14th century—four show historiation.

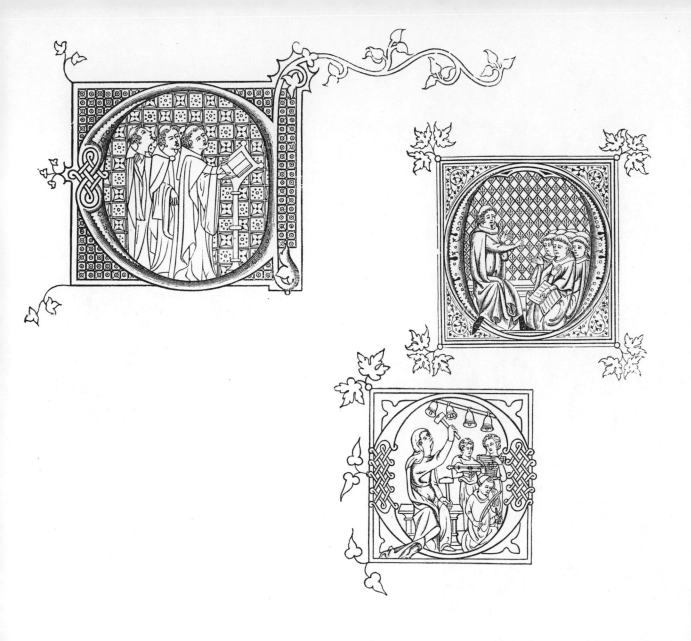

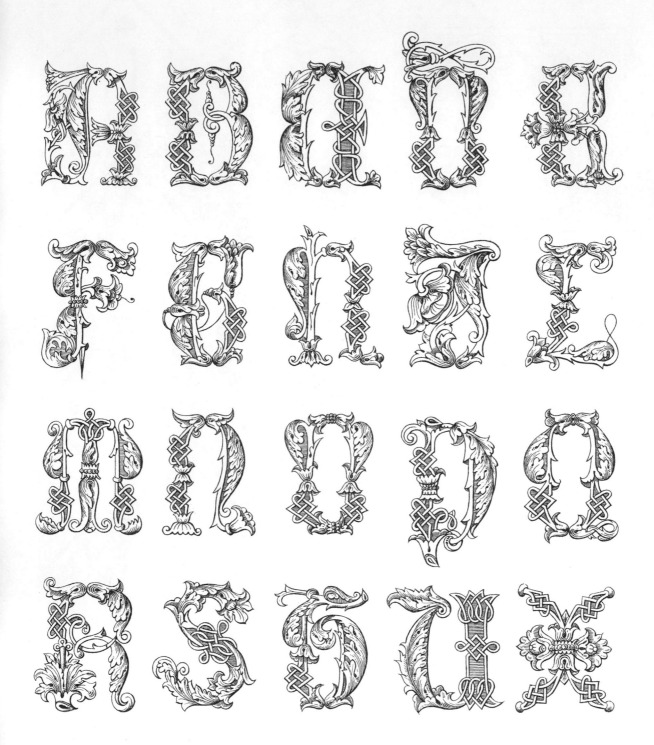

Plate 20. A 14th century alphabet taken from a missal in the Vatican Library.

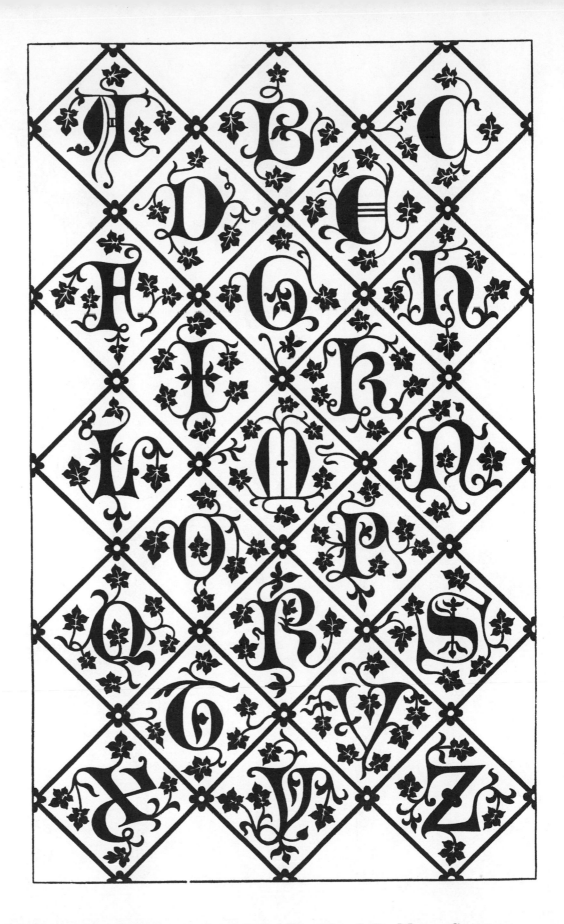

Plate 21. From an embroidered altar-cloth, Church of St. Mary, Soest, Germany—14th century.

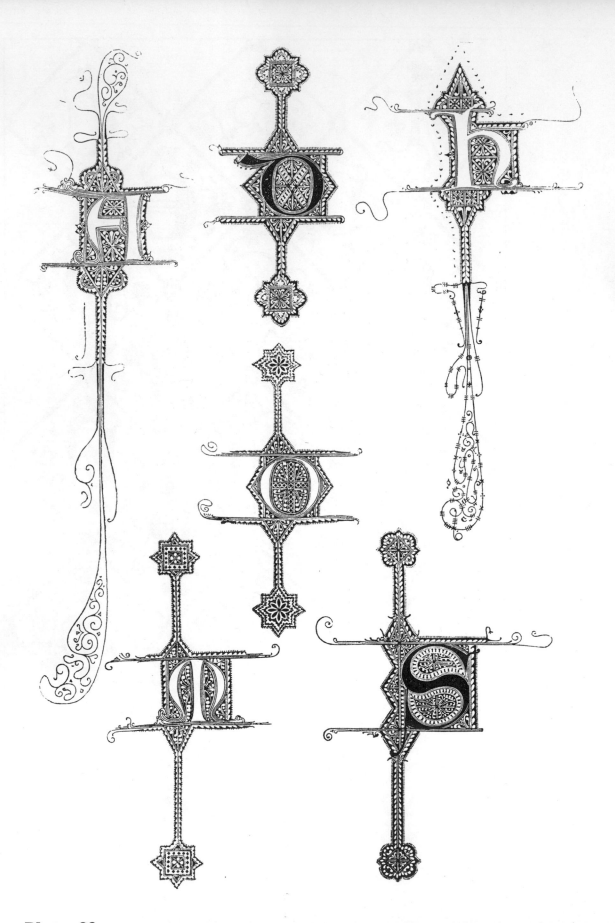

Plate 22. From a manuscript written for Robert, King of Naples—early 14th century.

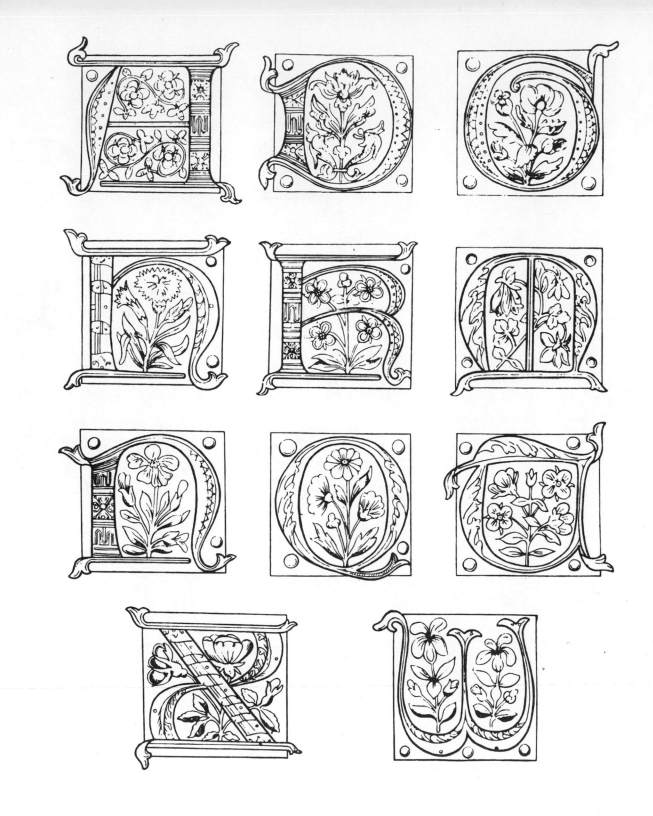

Plate 23. French, 15th century—naturalistic flowers in sweet colors, on a gold ground.

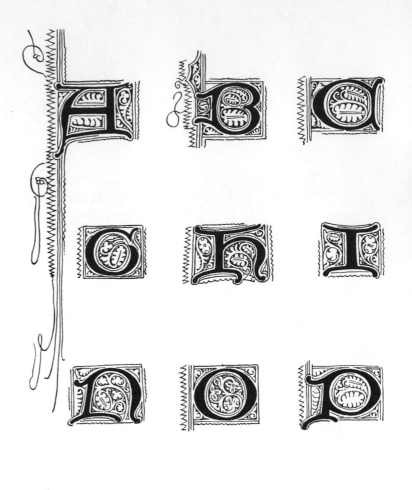

Plate 24. Red letters on delicate ornament, 1400—note gradual fading of severe style.

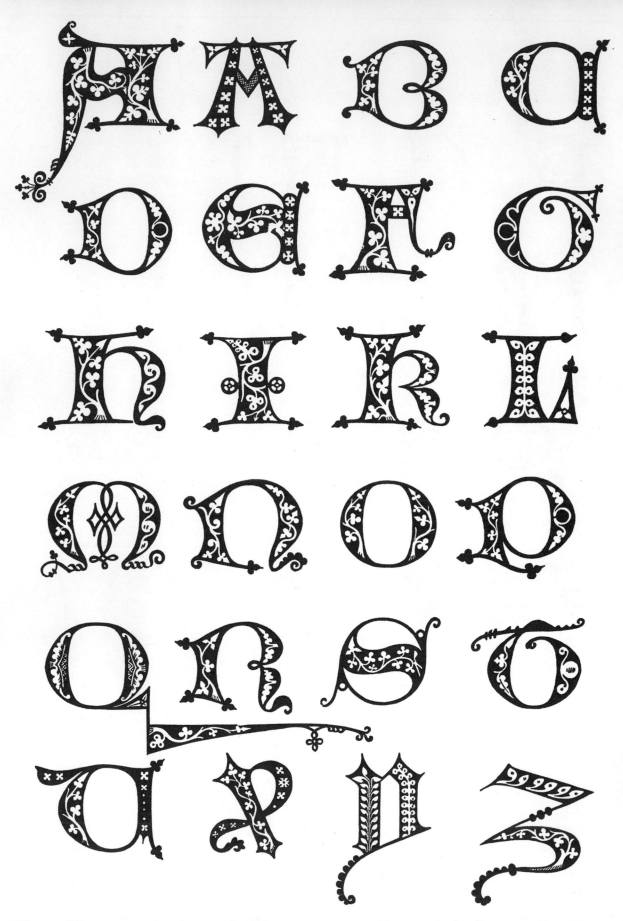

Plate 25. Decorated uncial initials of about 1475—such designs appeared also in printed books.

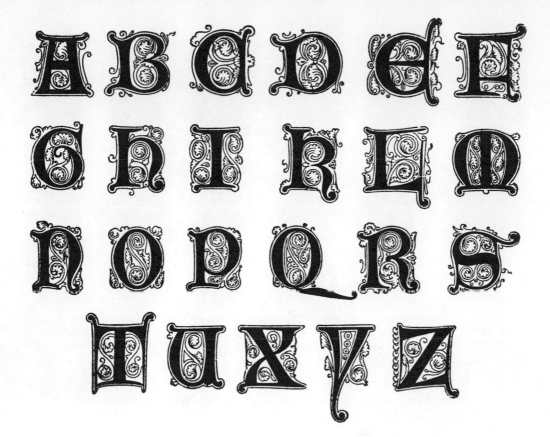

Plate 26. Gothic manuscript initials based on uncials—1480; printing is some 25 years old.

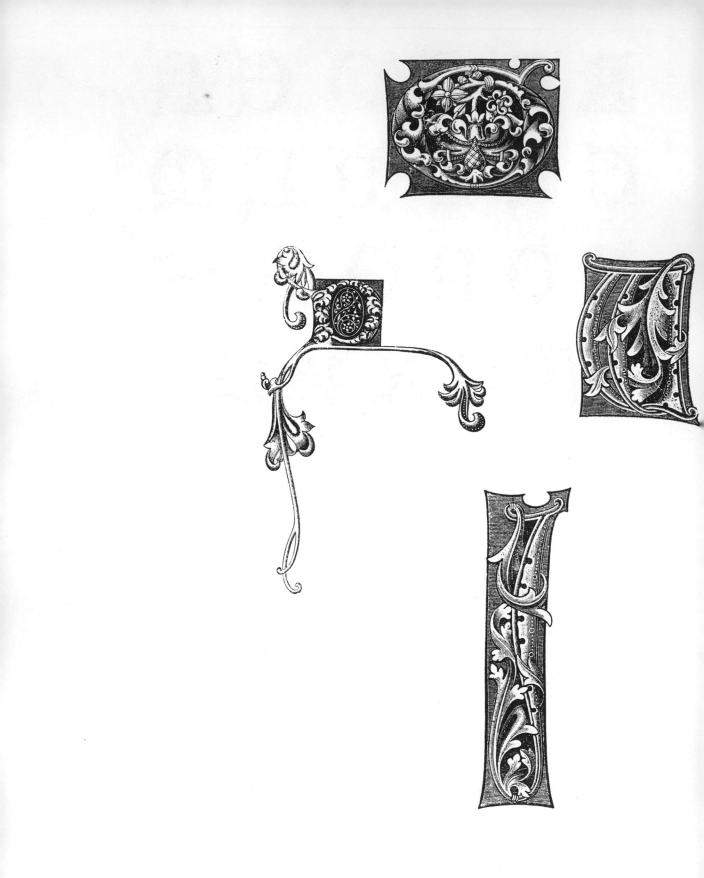

Plate 27. The finicky sort of work that was put into late manuscripts and early printed books.

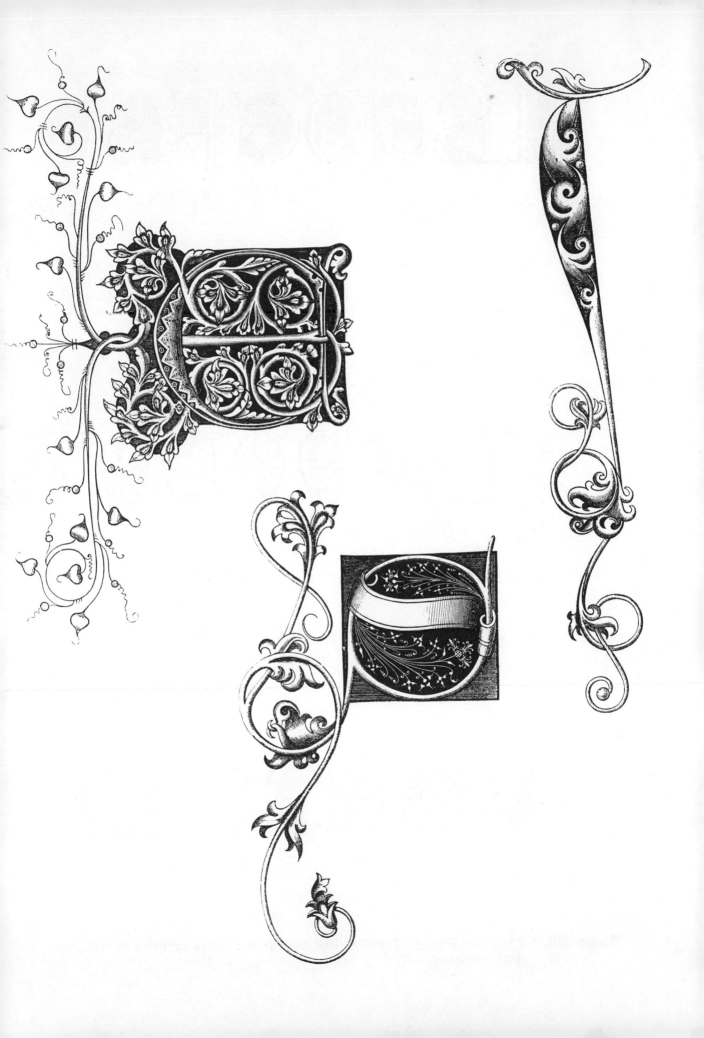

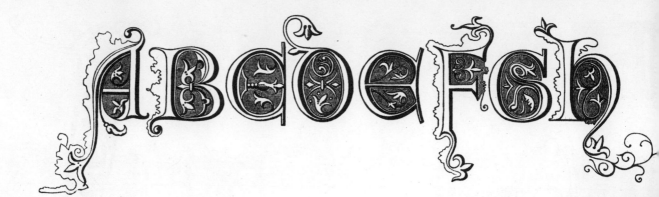

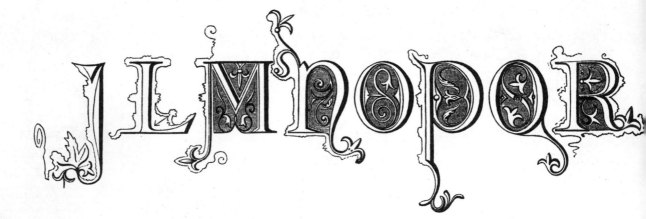

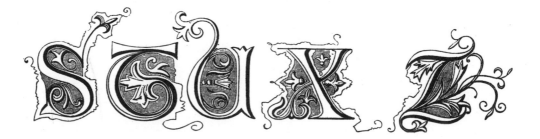

Plate 28. This is the kind of initial that decorated early printed books—late 15th century.

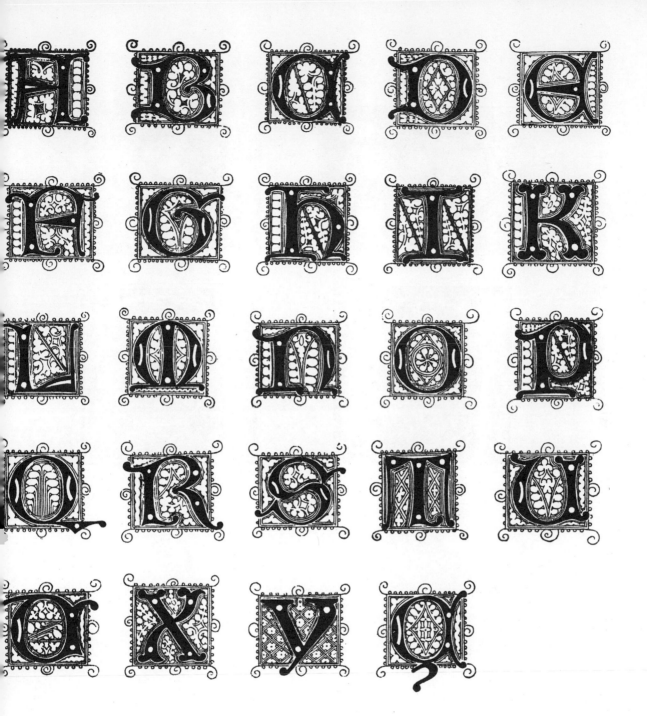

Plate 29. Letters surrounded by penwork doodling—from a 16th-century chorale, Monte Cassino.

Plate 30. Branch and ribbon letters, 16th century—usually executed on gold in pretty colors.

 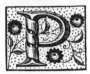

 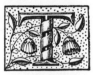

 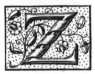

Part II Initials in printed books, 15th century through the 18th.

The fanciful initial followed an unbroken tradition from the manuscript book into the early output of the printing presses. It took some time to separate the scribe entirely from his long association with the book. For several generations the art of the illuminator, the work of the rubricator, continued on — as a kind of concession to traditional taste in the appearance of the fine book. The printer left openings in his text for hand-drawn initials, which, very often, were never inserted as the practice of rubrication languished. More and more the printer took it upon himself to print the entire book, initials and illustrations, along with the text. In the design of his initials and ornament he could not help but be influenced by the thousand-year development of manuscript designs.

Günther Zainer's lily-of-the-valley letters represent a direct continuation of late-Gothic manuscript initials. The motif itself was a popular one, and was incorporated into designs by several early printers. Some of the first woodcut letters appear to be just a framework for hand-coloring, which could, of course, be done carefully or carelessly; early printed initials were often spoiled by being daubed over with color.

At the very beginning of printing the attempt had been made to use initials in more than one color: the Mainz Psalter, published by Fust and Schoeffer in 1457, was a magnificent effort in multicolor printing. Gutenberg and his assistant, Peter Schoeffer, had tried, both in the 42-line Bible and the preparatory work on the Psalter,

to approximate the appearance of the written book. In the Bible, though, initials had been left to the scribe; but the conception of the Psalter was that of a printed work in the grand manner of the great manuscripts. The two-color initials were so ingeniously printed that they puzzled experts until quite recently. Undoubtedly the whole production scheme was costly and somewhat impractical. The initial in more than one color is uncommon in all of printing history. Erhard Ratdolt experimented considerably with color-printing; but his main approach, as far as initials were concerned, was simply to print the large letters in a second color — which, with his lovely initial designs, was a truly grand effect.

The incunabula printer accepted the initial letter as it had been relayed to him in the contemporary written books; he had similar designs cut in wood or type-metal, and locked them into his typographic form for the printing process. Gradually, the woodcut or metal-cutting techniques influenced the design of initial letters, especially the historiated variety. The alphabets of children or cherubs are typical of this development. It leads from the bold, simple effects of the Venetian printers to the highly evolved technique of the German-area woodcutters. There are good examples of this developmental procedure in the present collection. Birds, beasts, flowers, legends, fables, allegories, and grotesque heads — all were subject matter for the early initial artist and his woodcutter. No doubt they were often one and the same person. The history of initials, though, is full of associations between artists, such as Hans Weiditz and Hans Holbein and cutters such as, Jost de Negker and Hans Lützelberger. By 1530 the so-called "formschneider" in the German area had reached the height of perfection in producing woodcut alphabets.

By the first half of the 16th century the more or less international character of Western Europe began to change. France gradually became a great and dominant national power, which extended its cultural hegemony slowly over all the west. French initial-designs, though they were inspired by Italian Renaissance printing, were to become a major influence throughout Europe and continue in use into the 20th century. The designs of Geoffroy Tory and his followers were copied in the Netherlands area when it became the dominant printing center, and were even revived in the work of Frederic Goudy and Bruce Rogers during our own century. Arabesque patterns, that are based to some extent on the initials and ornament of Jean de Tournes of Lyons, have also influenced initial-designs practically to the present.

It was sometime during the early 1500's, too, that clichés of initials seem to have been produced in France. The printer no longer used original wood- or metal-cuts, but purchased initials cast from matrices or molds. It is significant that Claude Garamond became the first independent type founder around 1546; up to this time each print-shop had its own foundry, or borrowed, bought, or inherited type from another printer. Initials, especially, were passed from one printer to the other; the worn-down initials of the Paris and Lyons presses, for example, often appeared in the work of the provincial printers.

The virtuoso writing-master concerns us next, as a source of initial-designs. Many of the manuscript writers, gradually displaced from book manufacture, began to

occupy themselves with the problems of business or personal writing. Dissemination of knowledge, or at least literacy, was vastly increased by the greater possibility of obtaining books; so, to balance this greater number of readers it was necessary to teach more people to write. Therefore, the scribal profession tended to transform itself into that of the writing-master. During the 16th, 17th, and 18th centuries, most of the important writing-masters published books on writing methods and styles. Some pages of every such book were usually given over to examples of initials; and a few of these pages have been reproduced in this section to help round out the collection.

Until the end of the 16th century the usual method of printing the writing-masters' copybooks was from wood blocks. The penman employed a woodcutter to convey his letter-designs to the printing surface. Copperplate engraving replaced the woodcut as a reproduction process for these copybooks. This coincided with the change from broad-pen writing to the styles brought about by the use of pointed, deeply-cut, flexible pens. The printed book of the 17th and 18th centuries often used engraved initials; although this entailed an accurately-placed second impression in a quite different printing process. Writers on the subject of initial letters state that the fine woodcut initial ceased to be produced after 1580. This is not strictly true. Papillon's 18th century initials were cut in wood; and the woodcut technique — mostly wood engraving on end grain — was used through the 19th century to the present

All typographical and bookmaking craftsmanship were adversely affected by a variety of factors during the 17th century. The Thirty Years War, that completely disrupted the German area was such a factor; drastic censorship and repression in England and France were equally important in the decline of the art of the book. Increase in production and the attempt to cheapen it may also be noted as contributing to the general falling-off in quality and style. This does not mean that there were not some fine books nor sets of interesting initials; but it is obvious to the student that neither the books nor the initials were of the standard set during the incunabula period and the first half of the 16th century.

The initials of Papillon, that bring this section to a close, take us past the middle of the 18th century and into the era of the industrial revolution, which was to destroy all style and, in the end, threaten all craftsmanship. Andrade's and Baurenfeind's rococo alphabets represent almost the last manifestation of style in its original sense. By 1760 — the date of Papillon's pages — Baskerville, in England, had jolted the careless and smug English printer by publishing his meticulously printed books. It was Baskerville, however, who avoided all use of decorative initials. He was followed in this respect by Bodoni and Didot in Italy and France; although Bodoni did use some engraved initials, as did Ibarra in Spain. But the great use of ornamented initials in books was past; and it was to be under quite other circumstances and for quite different purposes that the bewildering 19th century development of the decorative letter was to take place.

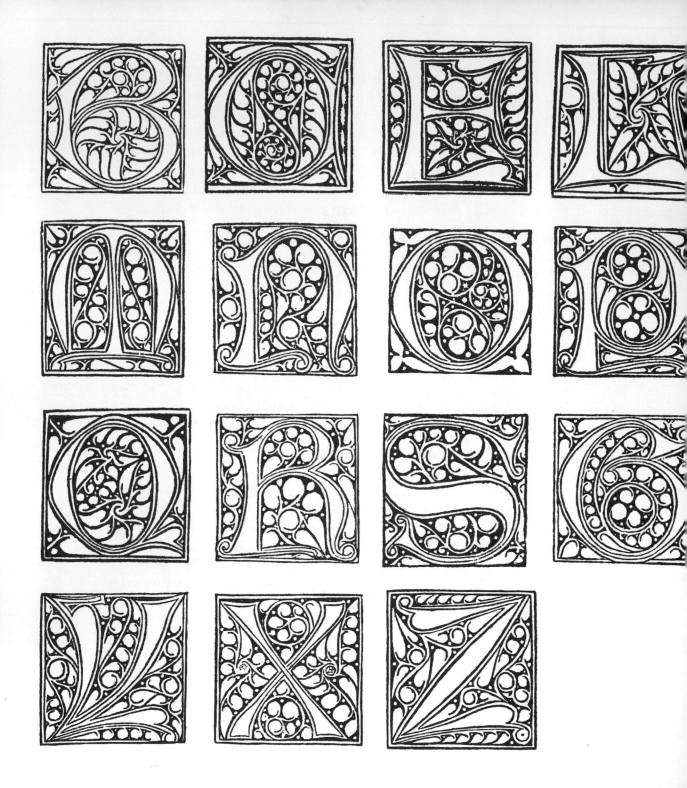

Plate 31. The famous lily-of-the-valley alphabet used by Gűnther Zainer at Augsburg, about 1475.

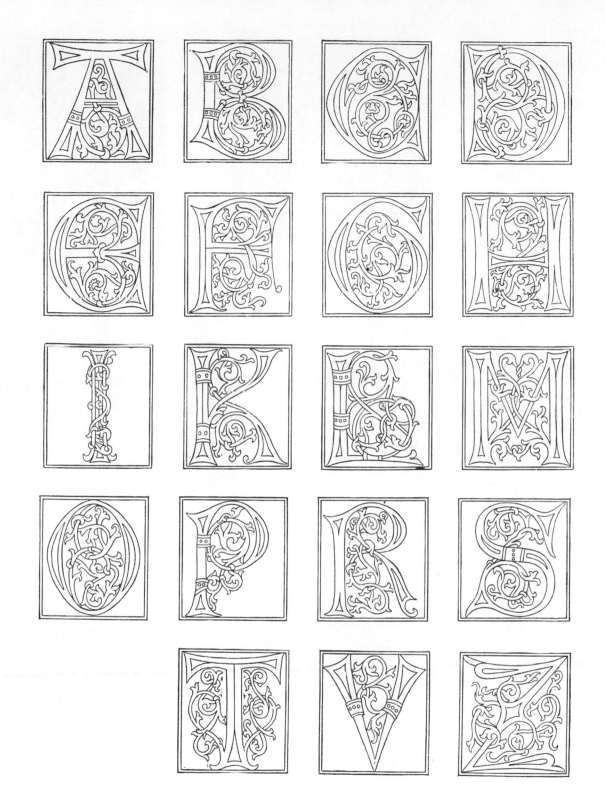

Plate 32. A set of designs used by various Augsburg presses, 1473-1482, often hand-colored.

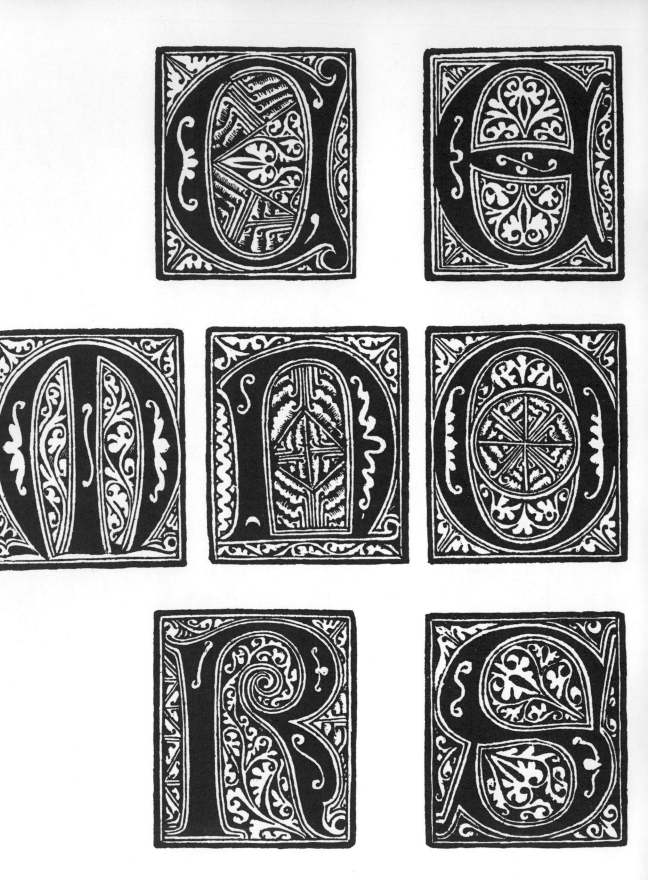

Plate 33. From a Venetian missal—late 15th century, Gothic in effect.

Plate 34. A set of illuminated initials from a printed book, presented to Cardinal Sforza—1490.

Initials were in color on a background; several letters were
added to complete the alphabet.

Plate 35. A simple and charming set of Venetian initials—Philippus Pincius, 1504.

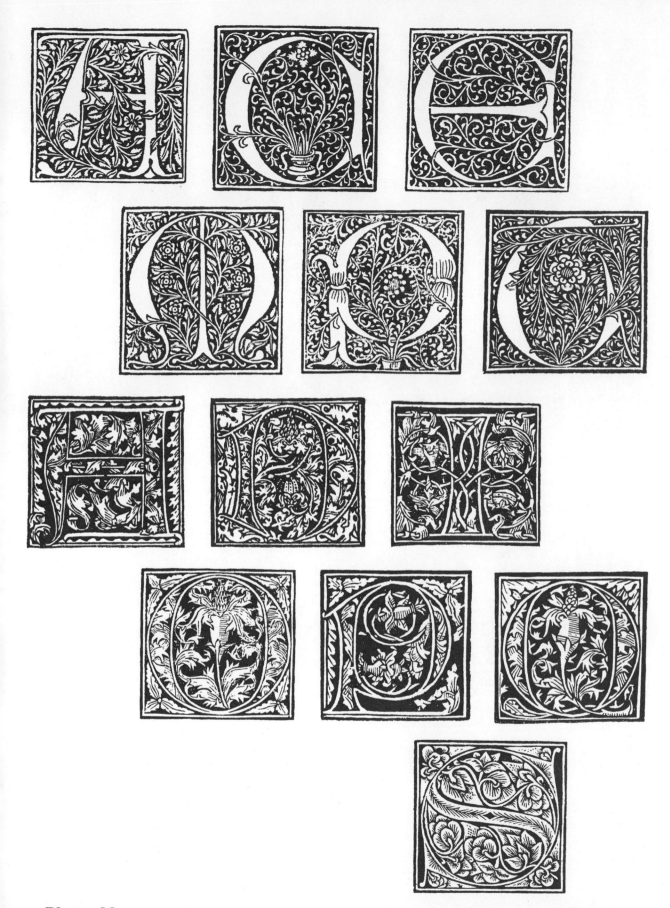

Plate 36. The early German printers in Spain used initials such as these, 1492-1497.

Plate 37. Initials used at Lyons and Paris, based on pen-written letters—
about 1500.

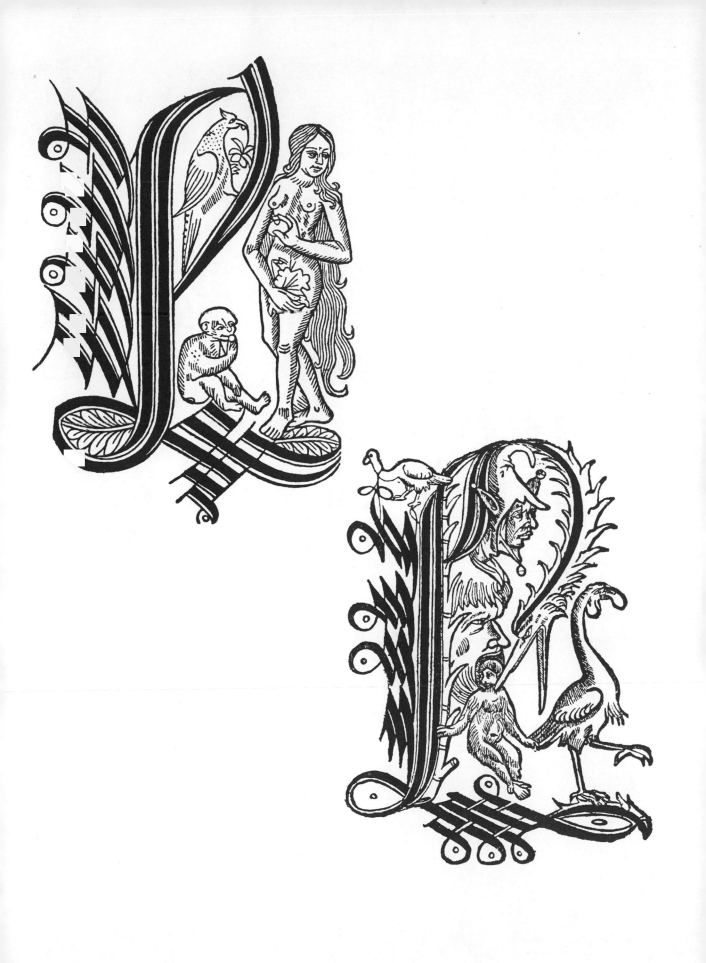

Plate 38. Gothic initials with grotesque faces—used at Troyes by Jean Lecoq.

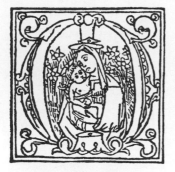

Plate 39. The printing center of Lyons used these initials during the first quarter of the 1500's.

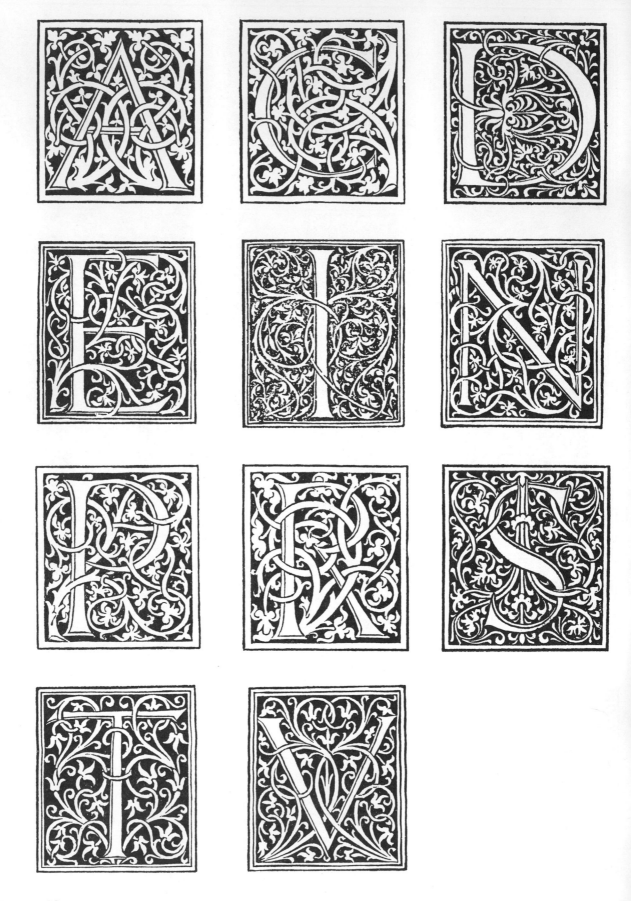

Plate 40. Some of Erhard Ratdolt's initials, showing use of italianate ornament, 1476-1486.

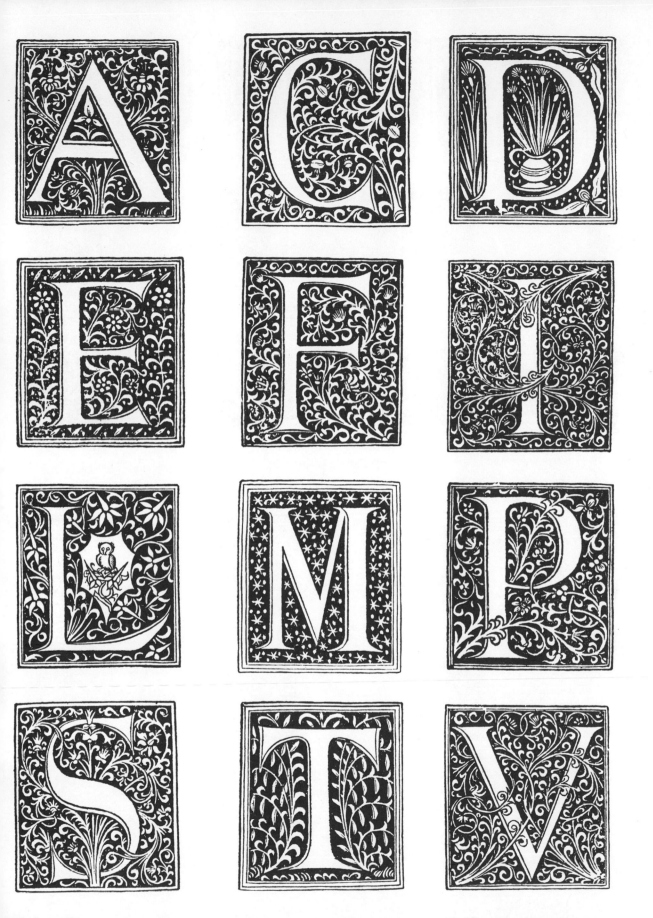

Plate 41. Jacob Köbel's initials, 1518—Italian influence on the German printers.

Plate 42. Initials in the criblé manner, possibly cut on metal—Andre Bocard, Paris, 1491-1531.

Plate 43. A kind of initial used in the late 15th century—these at Lyons.

Plate 44. Children and animals, Venetian inventions used around 1500.

First used by the printers Capcasa and Tridino—they were often imitated.

Plate 45. Initials from the Ferrara-Florence area, apparently used by various printers—1497.

Plate 46. Birds, beasts, and flowers—used by Jacques Sacon, Lyons, 1519.

A B C D E

F G H I K

L M N O P

Plate 47. Initials and stop ornaments from brasses in Westminster Abbey —15th and 16th centuries.

QRSTU

VWXYZ

Plate 48. Shaw's copies of initials from the *Missale Traijectense*—1515.

Plate 49. Date 1530—such initials could be woodcuts or might be inserted by the rubricator.

Plate 50. Taken from a copy of the *Romant de la Rose*—beginning of the 16th century.

These French-area designs are from the period when woodcuts
supplanted rubrication.

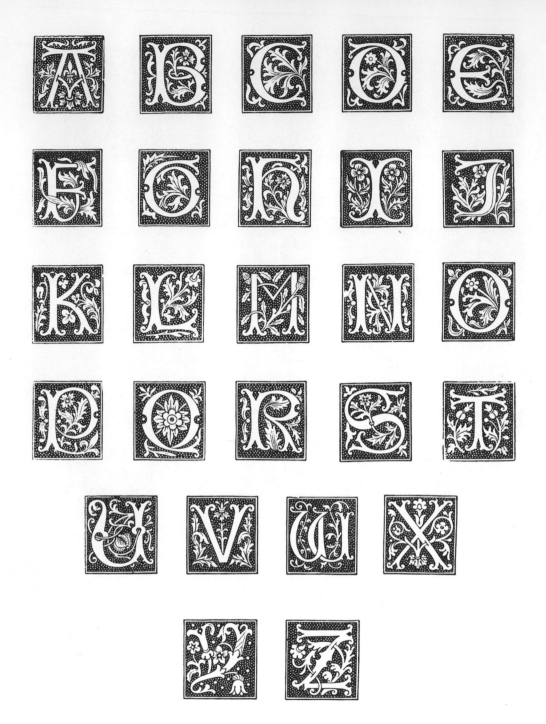

Plate 51. This set of designs was copied by Shaw from 16th century woodcuts.

Plate 52. Cherubs and children by Anton Woensam—used at Cologne, first half of 16th century.

Plate 53. Characteristic Lyons initials, used by John Moylin—1516.

These letters were inspired by the initials in Nürnberg and
Augsburg Bibles.

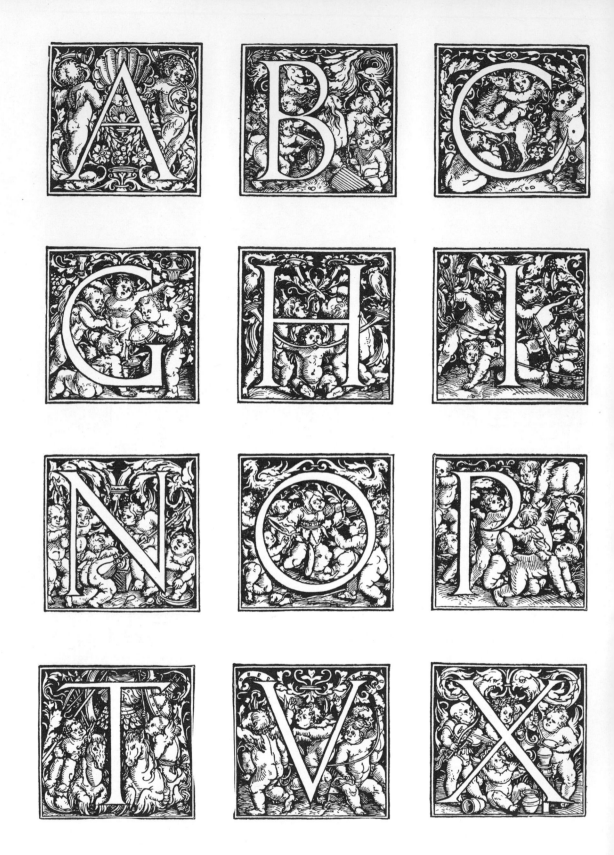

Plate 54. One half of proof-sheet of initials by Hans Weiditz, cut by Jost de Negker—1521.

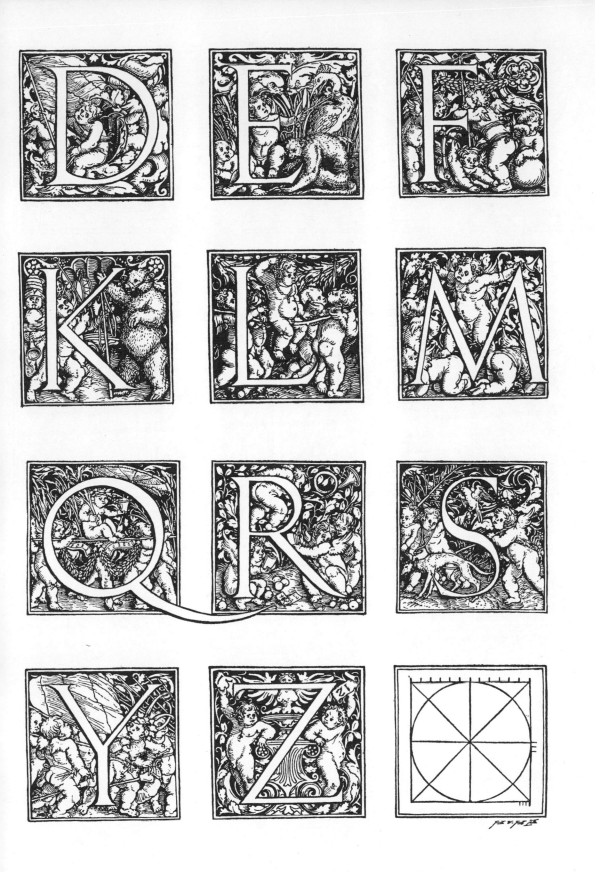

Other half of Weiditz sheet—these initials have often been attributed to Dürer.

Plate 55. Initials by Hans Holbein, used by the Basel printer Valentin Curio —1522.

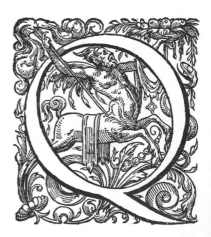

Plate 56. A set of letters used in Paris about 1568.

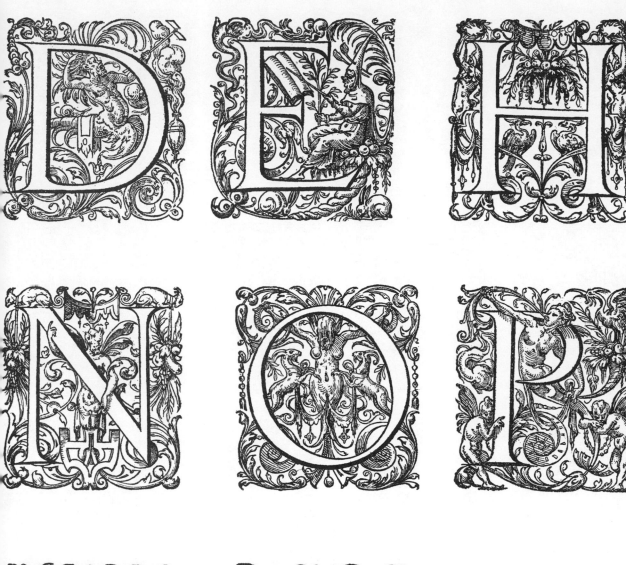
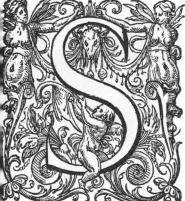

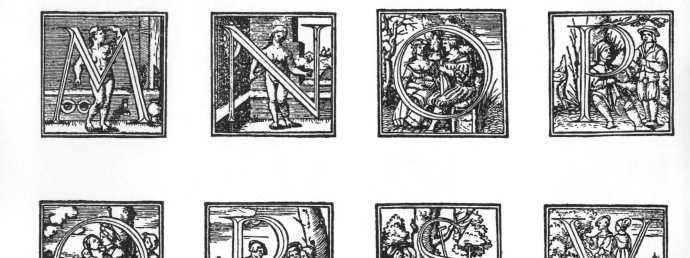

Plate 57. The female form and the vagaries of love—from the Egenolff press, Frankfurt, 1543.

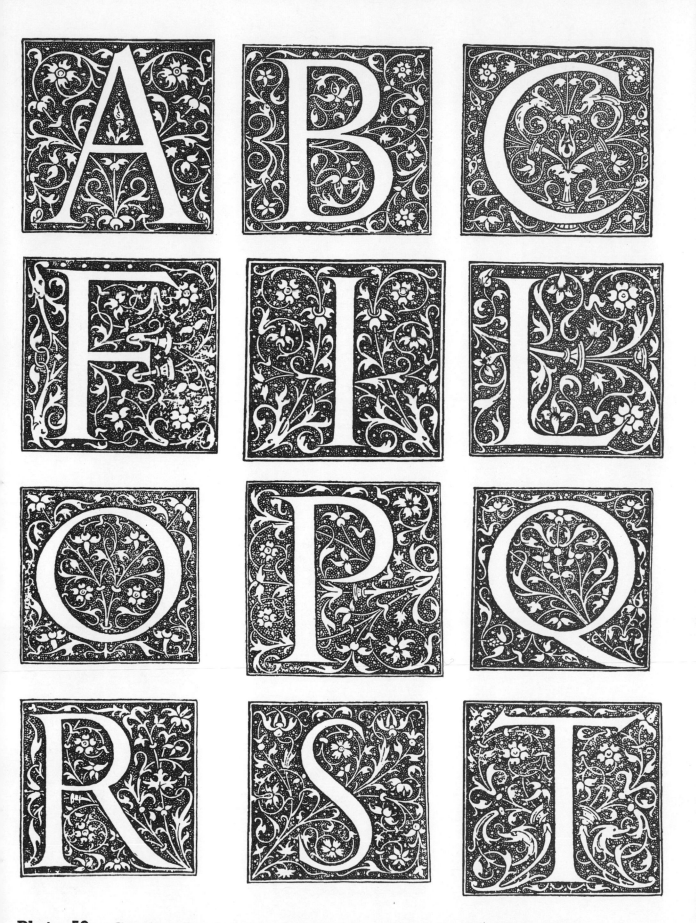

Plate 58. Geoffroy Tory's fame rests largely on these lovely initials—Paris, 1522-1529.

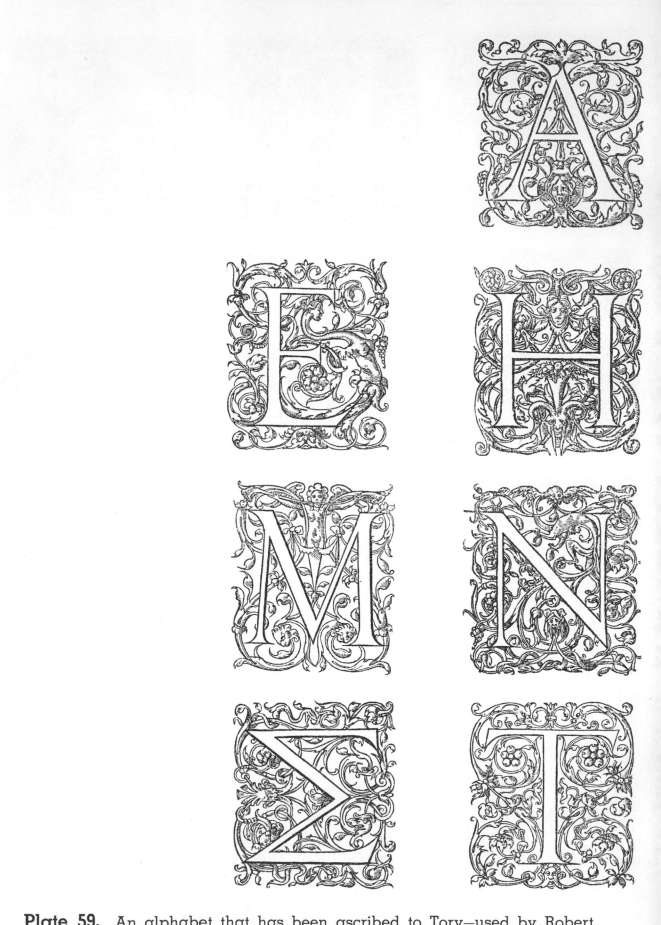

Plate 59. An alphabet that has been ascribed to Tory—used by Robert Estienne.

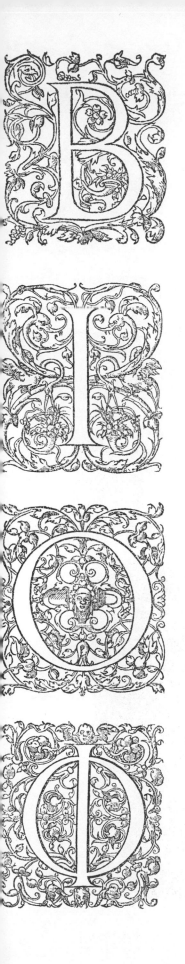
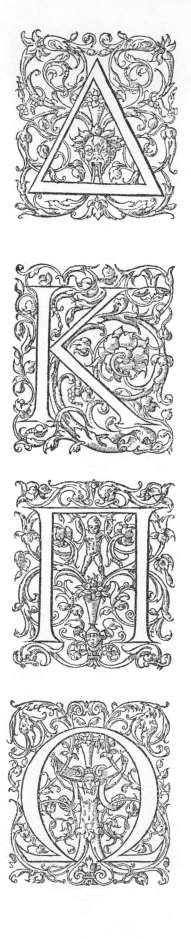
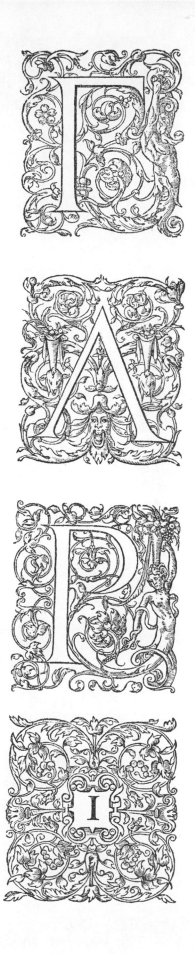

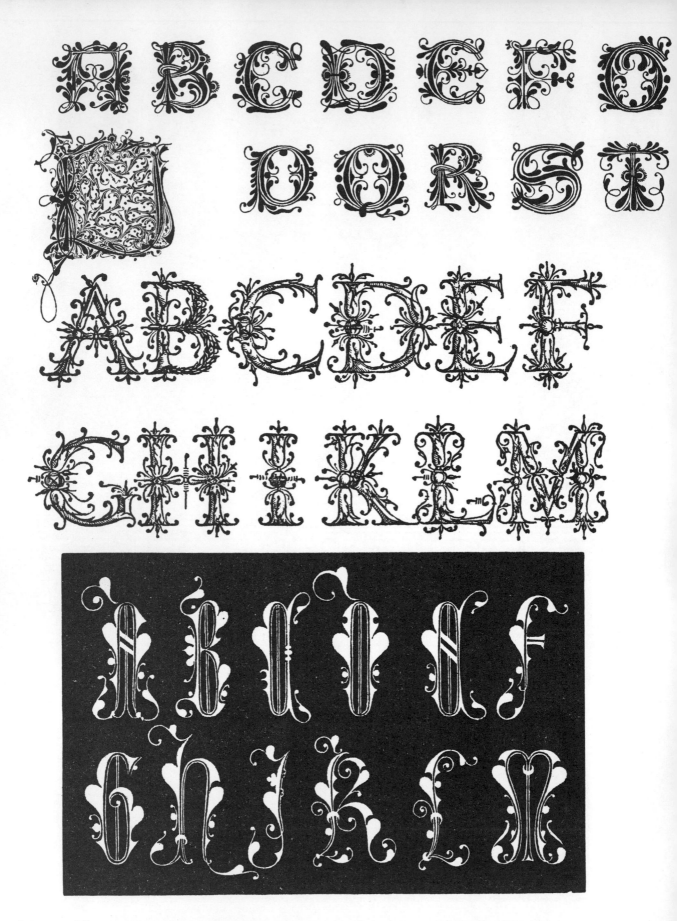

Plate 60. 15th century Venetian letters at top, center lines by Amphiareo, bottom by Cresci.

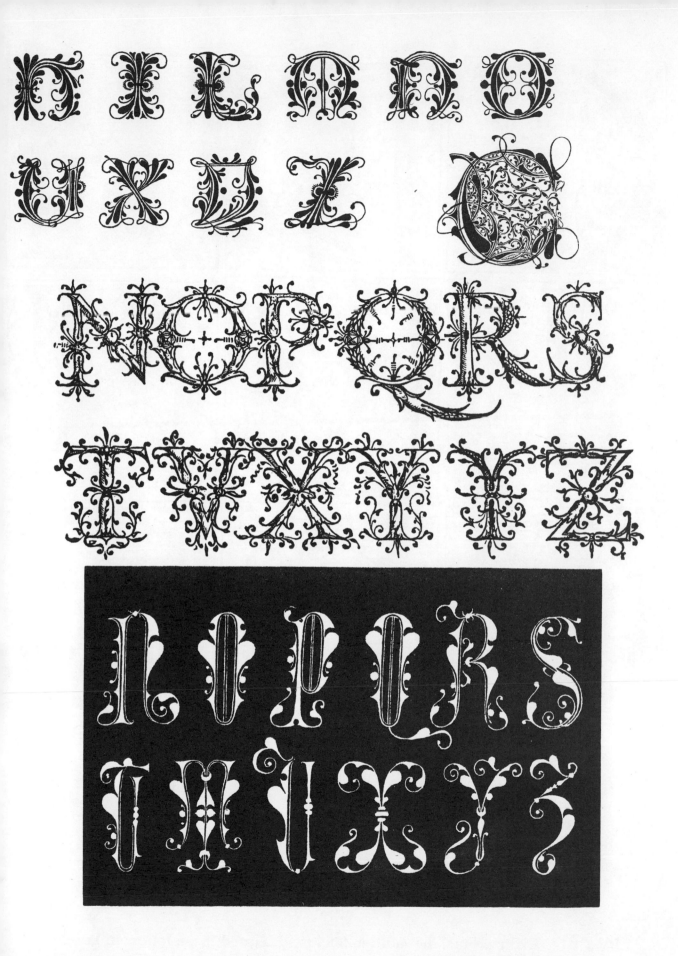

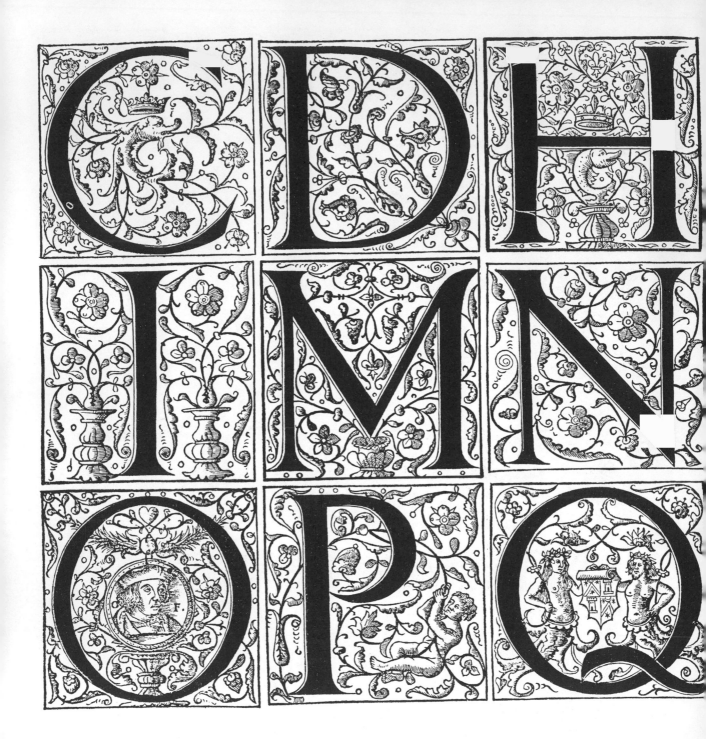

Plate 61. Oronce Fine, the mathematician, designed these letters in Paris —1532.

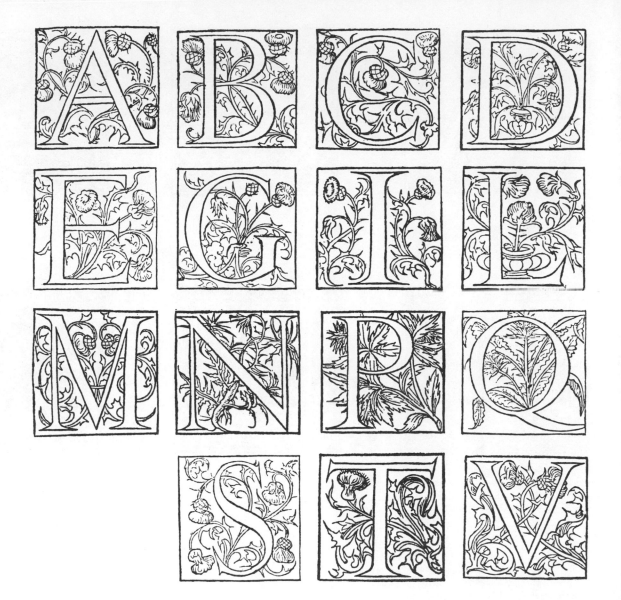

Plate 62. A set of thistle initials used by the printer, Denys Janot—1544.

Plate 63. A combination of German and French style—used by Jean Cres-
pin, Lyons, 1536.

A.

C.

Plate 64. Large pen initials from the writing-book of Vespasiano Amphi-
areo, Venice, 1554.

B.

D.

E.

Plate 65. Arabesques like these were popular after 1550—used by Jean Crespin at Geneva.

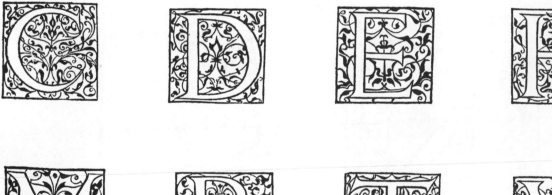

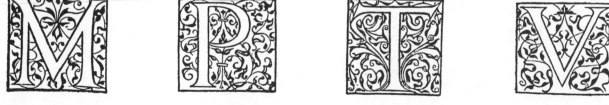

Plate 66. Two sets of French initials in the arabesque manner—latter part of the 16th century.

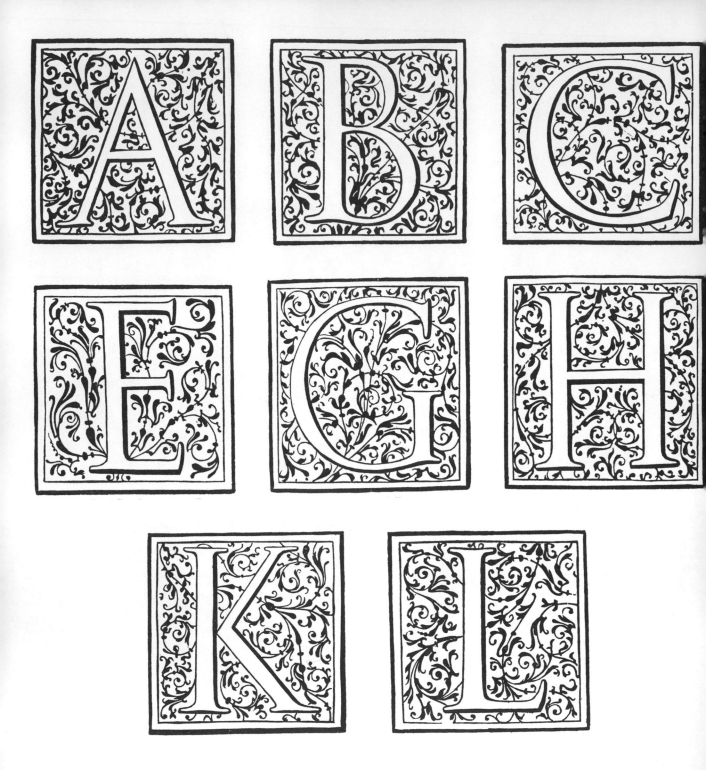

Plate 67. These initials are related to those used by Plantin and by Adam Berg.

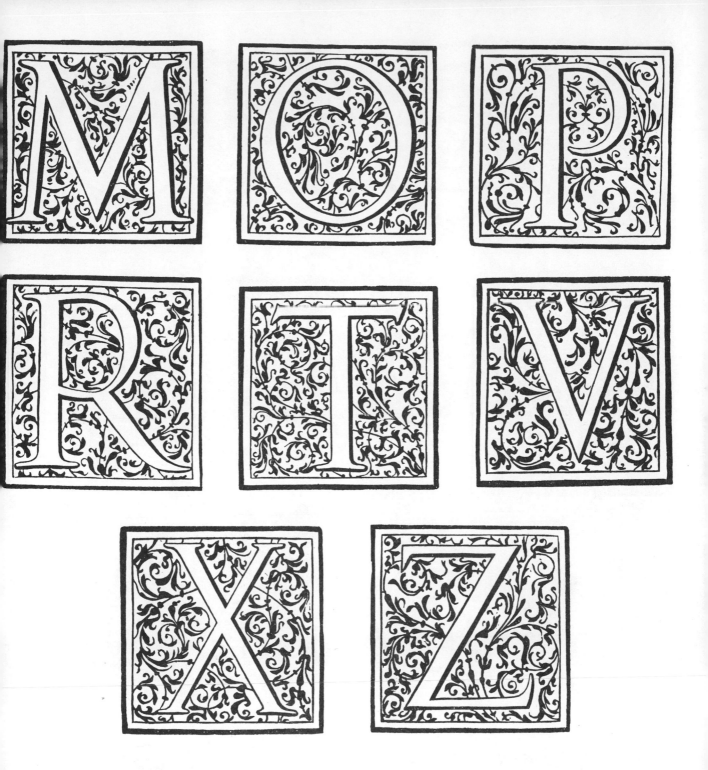

This sort of initial was used in music books about 1600.

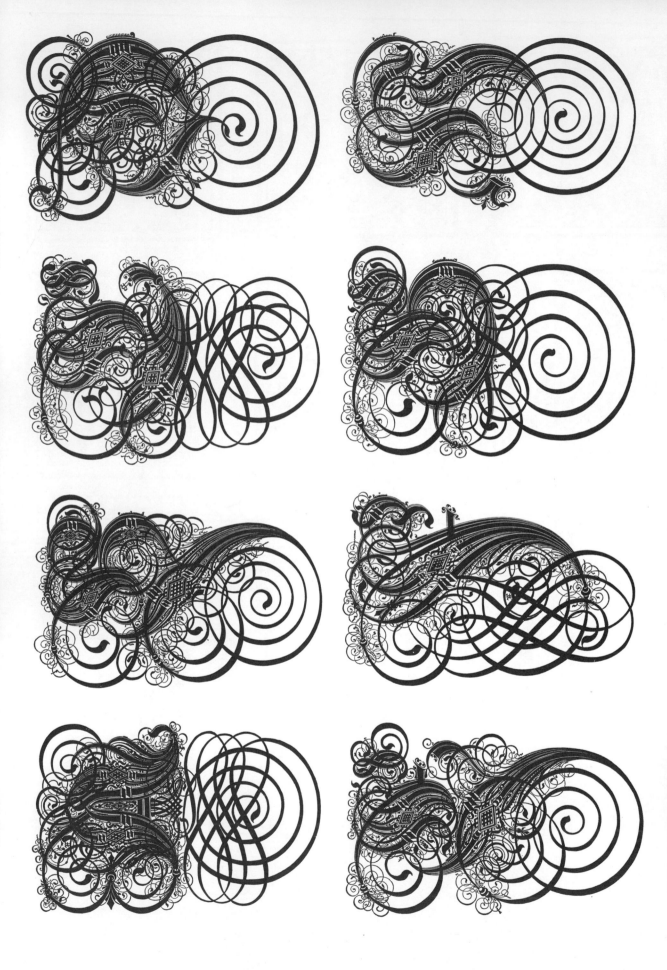

Designs by Paulus Franck—Schatzkammer, Nürnberg, 1601.

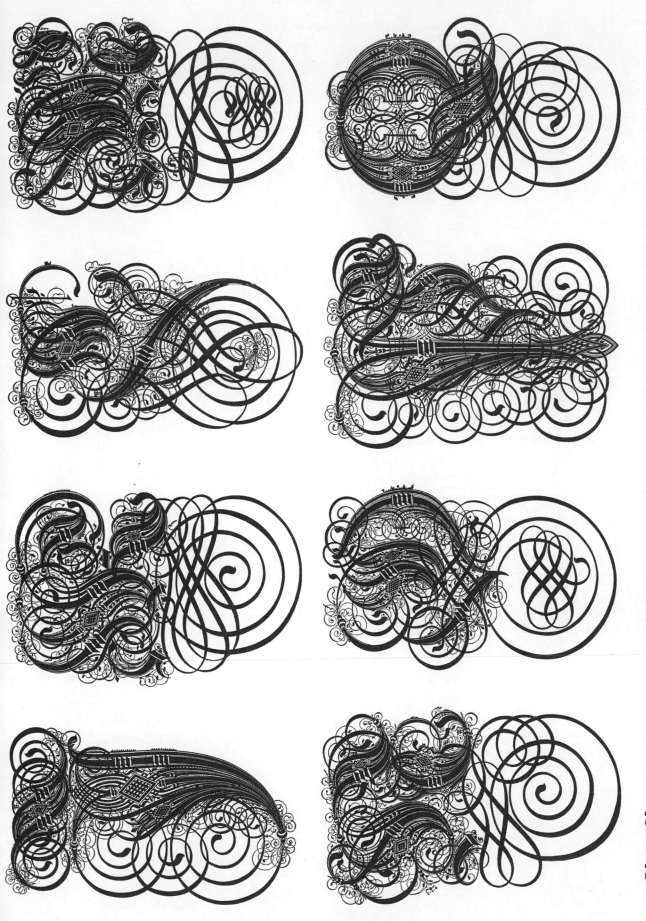

Plate 68. These letters may be looked upon as a complete study in flourishing.

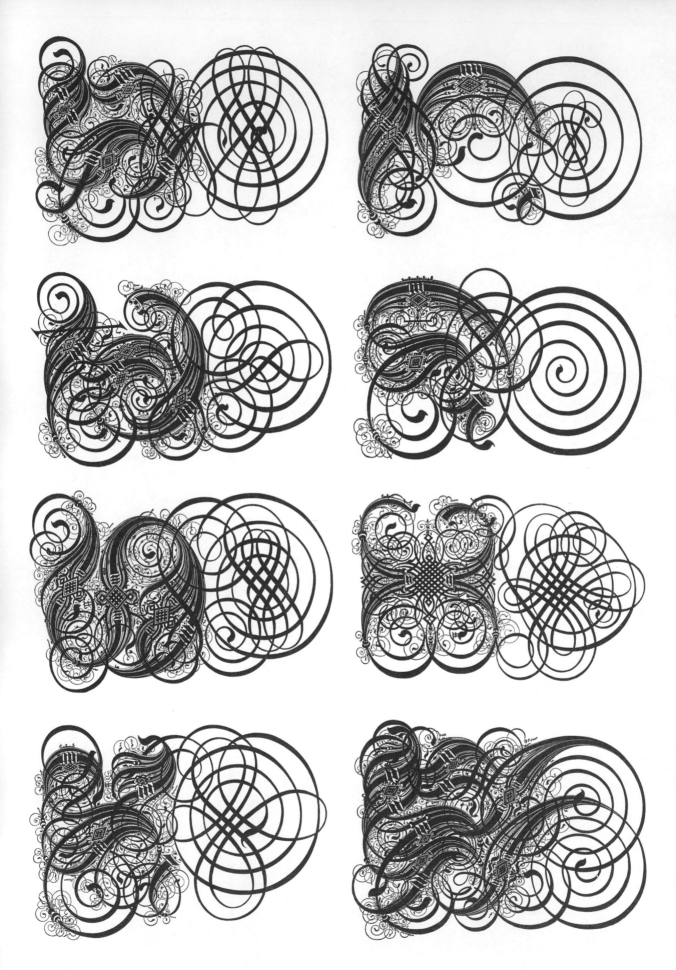

Plate 68. Baroque initials could go no further—they are almost as complicated as Kells.

Plate 69. Paulus Franck in a simpler style—also from the Schatzkammer.

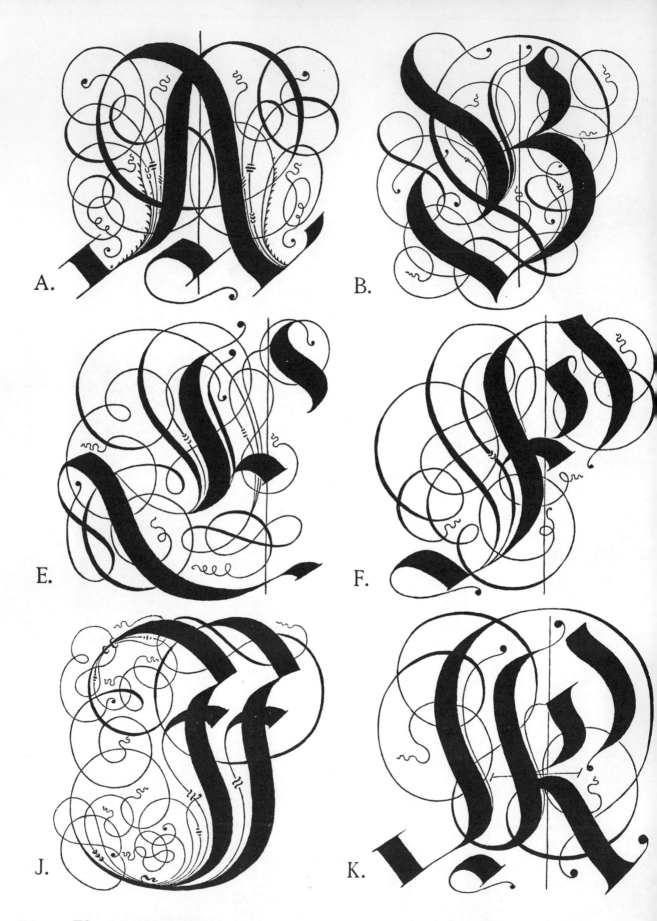

A.

B.

E.

F.

J.

K.

Plate 70. A simple style of baroque initial from the writing-book of Paul Franke—1655.

C.

D.

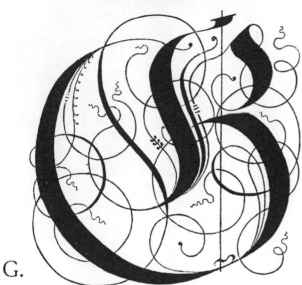

G.

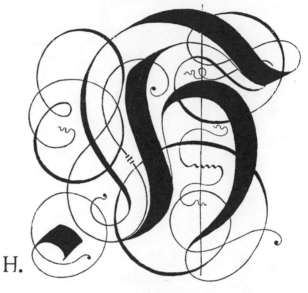

H.

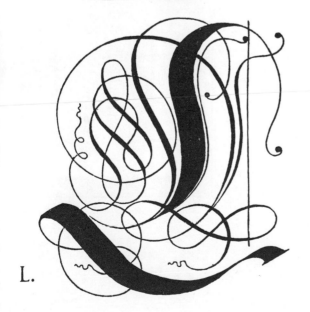

L.

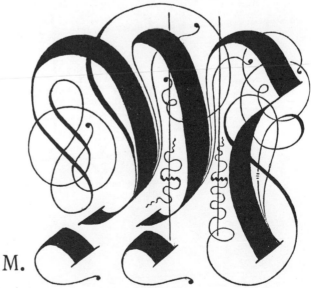

M.

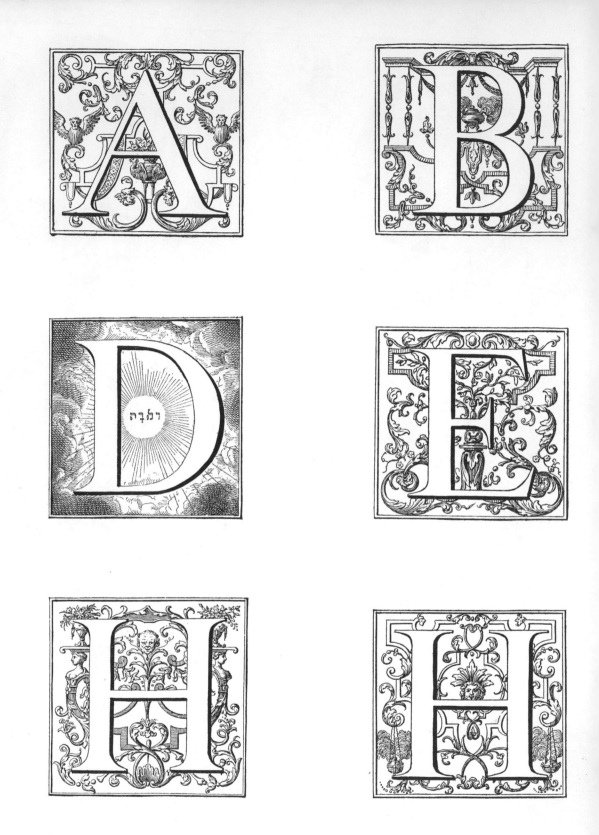

Plate 71. 17th century French designs that seem to fit the Louis XIVth period.

Plate 72. Dutch initials of the 17th century—the basket-of-flowers was a much-used design.

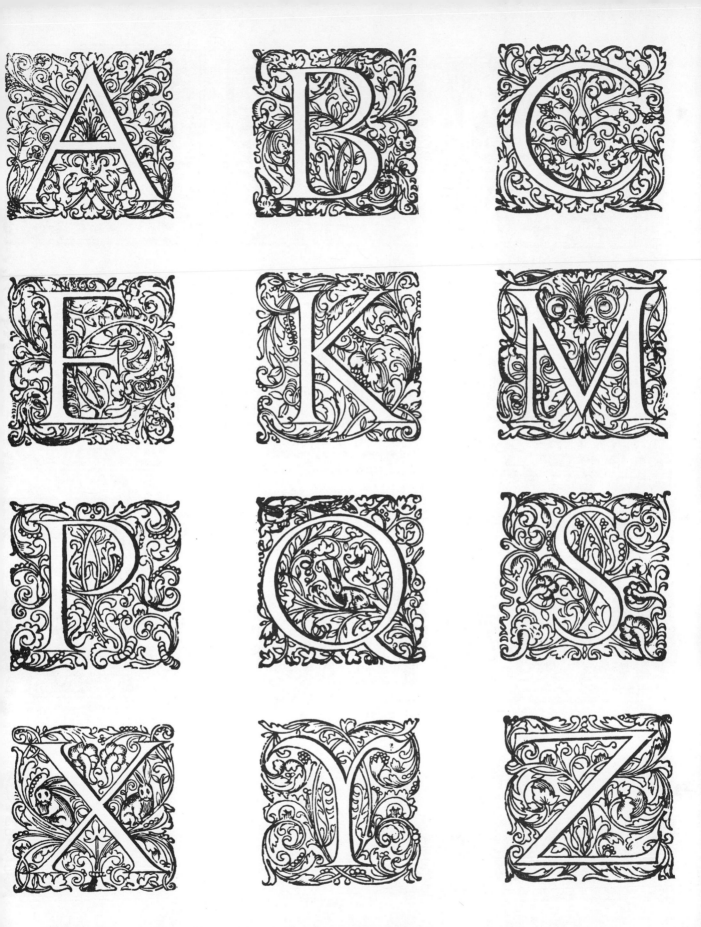

Plate 73. The blocks of these 17th century letters still exist at the firm of Enschedé, Haarlem.

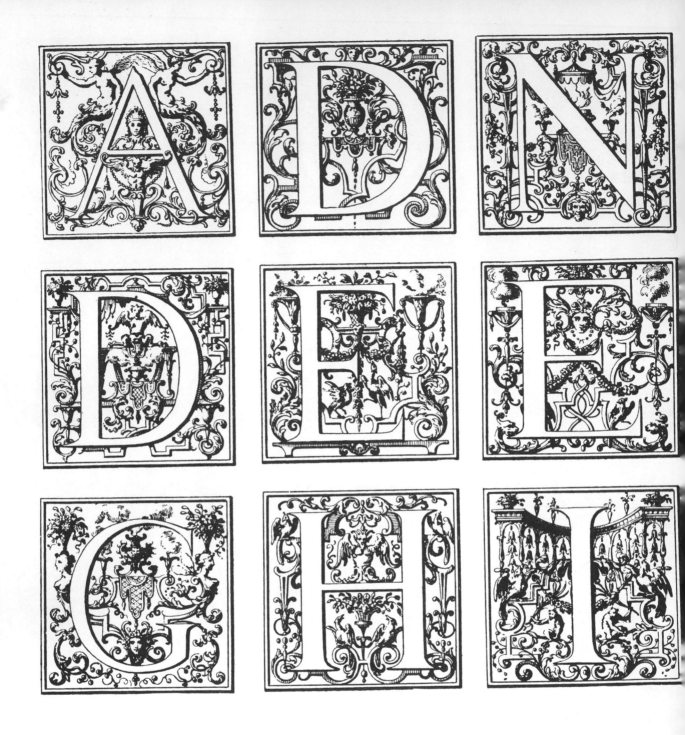

Plate 74. Initials were also produced by copperplate engraving—these are Dutch, late 1600's.

Plate 75. These letters were cut in metal by J. F. Rosart—bought by En-
schede in 1760.

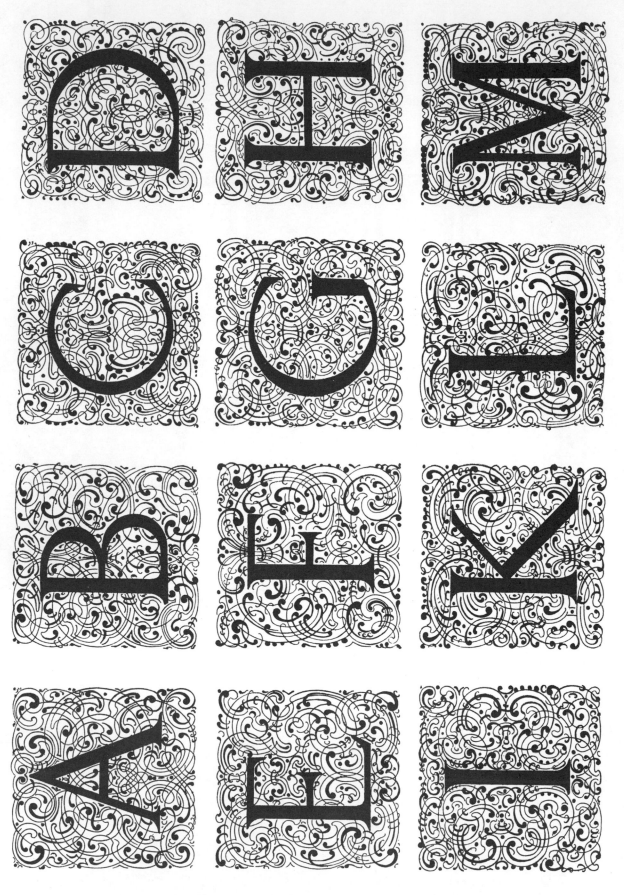

An alphabet by the south-German writing-master George Heinrich Paritius, 1710.

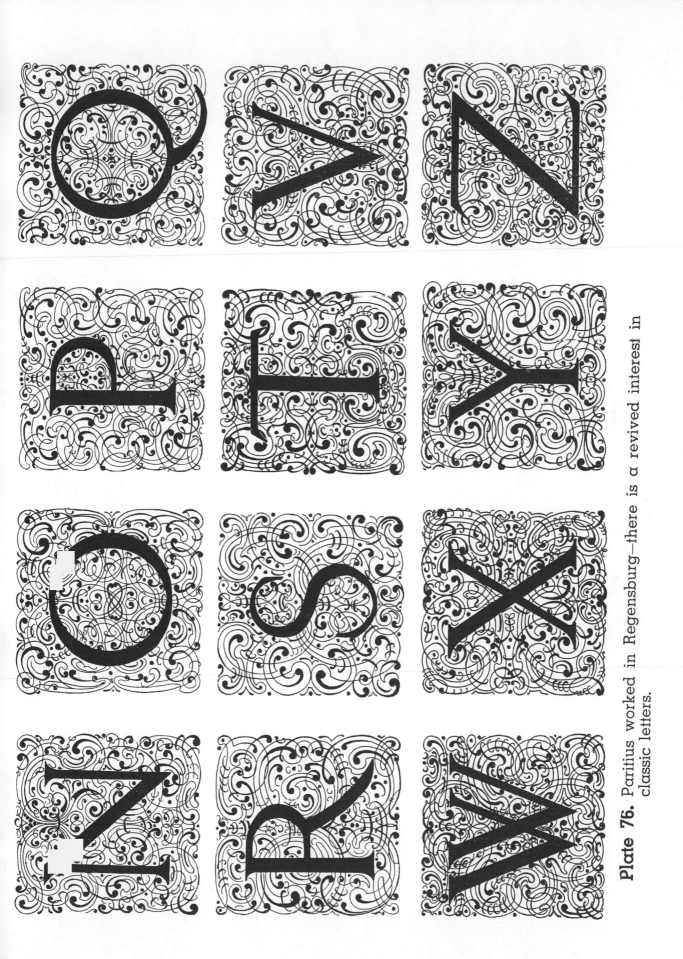

Plate 76. Paritius worked in Regensburg—there is a revived interest in classic letters.

A.

B.

C.

D.

E.

F.

G.

H.

L.

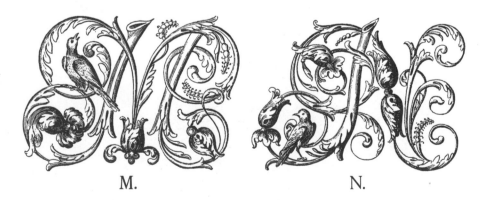

M.

N.

Plate 77. Rococo style with birds—Manoel de Andrade, Lisbon, 1719.

A a b c d e f g h i l m n o p q r
s t v u x y z .

a b c d e f g h i l m n o p q
r s t v u x y z .

A B C D E F G H
I L M N O P Q
R S T V X Y Z

Plate 78. Michael Baurenfeind's rococo letters—Nürnberg, 1737.

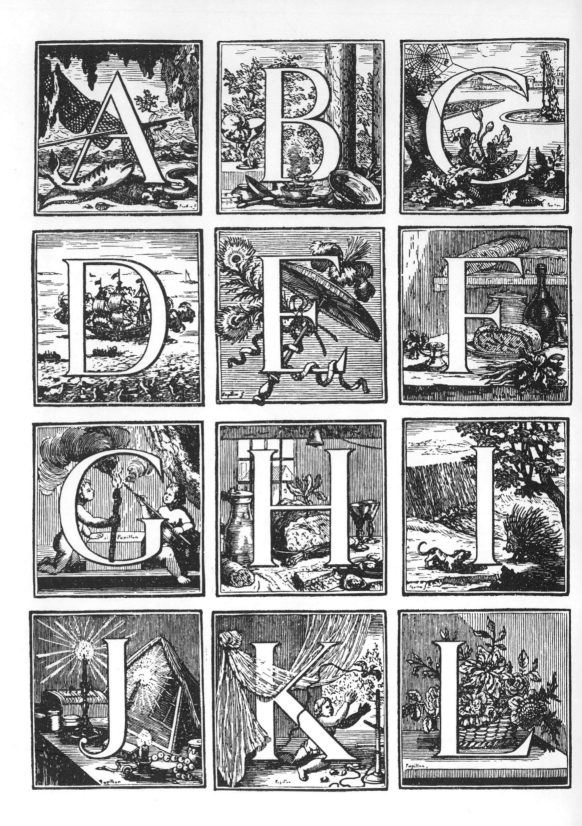

Plate 79. Woodcut initials by Jean Michel Papillon—first shown in Paris, 1760. Jean Michel was a son of Jean Papillon, the famous manufacturer of fine wallpaper.

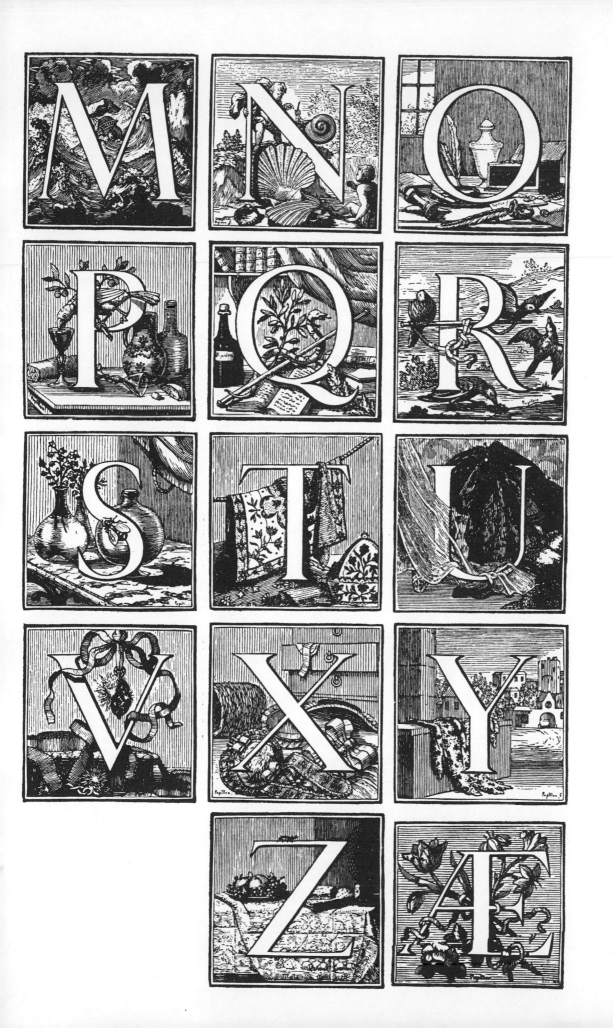

Part III Initials and decorative alphabets, 19th century to the present.

In the foreword to this book, the Victorian period of typography has been referred to as a great, weedy jungle — and this it truly is. The more one looks at the typographical production of the 19th century, the more bewildering it becomes. The first business of this note, therefore, is to relieve that bewilderment somewhat; and this can best be done by some consideration of the economic and cultural factors behind this typography.

It is in Victorian typography that one may study the 19th century decorated letter best — for the important reason that the English, for the first time in their history, dominated the typographic stage. England was the full and foremost inheritor of all the effects of the industrial revolution; in industrial development it was as much as a century ahead of some parts of the world. Since English methods and merchandise were accepted everywhere, it is not surprising that their typography had a great effect upon the countries of the continent and especially upon the United States. The industrial revolution did not take full effect in America until after the Civil War. The so-called Americana types of the late 19th century are often copies of English styles, often produced by European craftsmen — many were quite possibly importations from England or the type foundries of the continent. The latter, in turn, were copying English production.

One must remember that all this mass-production of goods corresponded roughly in point of time with the first comprehensive research into the art and design of earlier cultures. This newly-acquired knowledge was eagerly seized by English manufacturers and used with little discrimination or taste to "decorate" their products. Machine manufacture employed whatever historic style seemed convenient, pretty, or saleable; bastardized it wherever it appeared to be necessary; and produced the many articles of commerce and life in multifarious hybrid designs. It was a rather vulgar and tasteless procedure at best; the continental manufacturers followed the same practice. The craftsman, who grew up with his craft and inherited style, worked with it, and passed it on, was gone. One may say with confidence that style, in its previous sense, had come to an end. This condition was only too apparent in the typography of the time.

The industrial revolution clearly sponsored the confusion of all style: this is the bewildering element in 19th century decorative-letter design. That there was so much production — another aspect of the bewilderment — was due to the tremendous increase of printing for commerce, — direct advertising, or what was called job-printing by the English. This field quite outdistanced the printing of books as the printer's major activity. It was the great new business of advertising, that had to be started to market and sell the enormous volume of merchandise being produced by the new machines. Display types were necessary; and they were created in a profusion that has never been equaled. To add to the fever, lithography began to compete with printing — the lithographer and the type founder actually tried to outdo each other in the creation of strange and exotic letters. It is a little hard to say who won; but the foundries did pretty well on the evidence of their specimen books.

It is difficult to believe that in this welter of aberrations, distortions, and perversities, there were any dominant influences or directions whatsoever. But, there were. As in the English architecture of these times, there were two main streams of influence: the Gothic and classic revivals. In its purest condition, the Gothic revival appeared in the work of the Pugins, who were architects, and in the efforts of William Morris. Essentially, it was the Gothic book that Morris admired and sought to emulate. He used initials in abundance; and they were obviously based — as was his whole conception of the book — on the work of incunabula printers, such as Günther Zainer and Erhard Ratdolt. The classic revival did not have so great and active a protagonist; its typographic result was manifested in more roundabout ways by indirection generally; but it was there. Even Morris, although he disliked the Renaissance, copied the Jenson type; and, ultimately, all Renaissance printing style was revived.

The one-line captions beneath the examples indicate, for the most part, whether they were produced under one or the other of these major influences. However, there were Egyptian, Chinese, Indian, Japanese designs that crept into the scheme of things as well. One need not go into detail in explaining this. It is sufficient that the reader be aware of the endless copying and rehashing of all known earlier design. Terminology was affected: such a basic typographic name as Egyptian was certainly inspired by the installation of the first Egyptian collection in the British Museum in 1834. It

is of interest to note also that the architects of the museum, the Smirke brothers, were noted classic revivalists. Names, such as Tuscan, Ionic, Grecian, Italian, Latin, Antique, Monastic, Ancient, Runic, etc. surely reveal the ramifications of the Victorian type founder's interest.

As for the actual design, it may be said there were only three main methods of handling all these derivations from Gothic and Roman types or letters. The first method was to modify the shape or pattern, which really means aberration, distortion, corruption of what were originally satisfying aesthetic solutions. Secondly, there was the practice of decorating the face of the letter or surrounding it with some sort of shrubbery or doodling. Finally, the letter was often given outlines and dimensions, perspective effects of all kinds. The historiated letter, as a classification, was also extremely popular — being either enclosed by a scene or containing the picture within itself. Literally, there was no end to the invention, the imagination, of the Victorian letter-artist, whether lithographer, type founder, or pen-draftsman; but most of the myriad designs may be quite well classified within these three or four categories. There can be no category, of course, for letters made of rope, bamboo, icicles, human figures, branches, ribbons, etc. — they all have their precedent in early manuscripts. Not much of this sort has been shown, for the simple reason that it is somehow banal and tiresome.

Whether our 20th century will ever revive the use of the decorated initial is problematical; it has, however, revived the use of many Victorian types. They are not being employed in the manner of the 19th century though; but to produce definite effects in present-day advertising — for instance, a horizontality or verticality in the design of the page, or to give it a desired texture or emphasis. So, we have expanded and condensed Grotesques in very wide use; the wide Egyptians and Latins have been revived; Clarendon is in demand again. It is difficult to predict how far the current revival can go. We have the possibilities for aberration in infinity with the prisms, lenses, and mirrors of photo-typography and photo-lettering. The Victorian designer, at least, produced all his peculiar alphabets by hand and eye alone. It is possible that we have strayed into the same kind of typographic jungle in which the Victorians disported themselves, and for somewhat the same reasons. We are in the grip of fascinating and frightening new developments — a situation in some ways similar to the state of the Victorian world a hundred years ago. It remains to be seen whether we simplify or proliferate our typography and letter design, whether we really develop a style of our time or continue reviving all earlier material. In any case a book of fanciful initials, such as this, should have some value in explaining their history and use. All contemporary life cries out for simplification; but man, I strongly suspect, is very apt to remain a doodler and decorator, even of outer space.

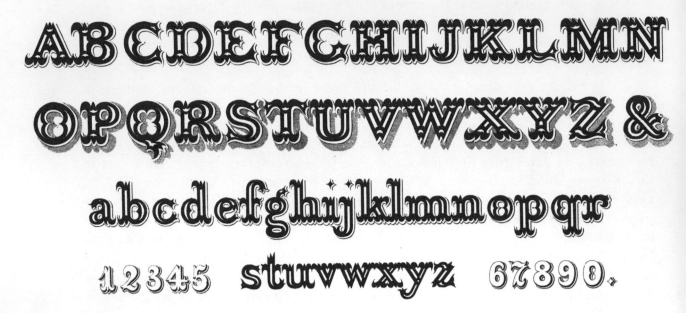

ABCDEFGHIJKLMN
OPQRSTUVWXYZ&
abcdefghijklmnopqr
12345 stuvwxyz 67890.

ITALIAN PRINT

ABCDEFGHIJKLM
NOPQRSTUVWXYZ
abcdefghijklmnopqrs
12345 tuvwxyz 67890

Plate 80. Two basic 19th century styles—Tuscan, with forked ends, and Italian.

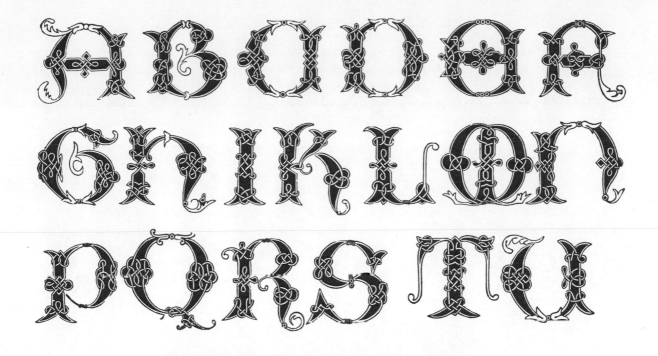

XVIᵗʰ CENTURY

A B C D E F G H I

J K L M N O P Q R

S T U V W X Y Z

Plate 81. Two 16th century designs revived for 19th century use—upper set is by Tagliente.

ABCDEFGHI
JKLMNOPQR
STUVWXYZ&

ITALIC PRINT, VARIOUSLY SHADED.

Centre ABCDEFGHIJKLM *Line*

Centre NOPQRSTUVWXYZ *Line*

abcdefghijklmnopqrstuvwxyz.

Plate 82. Here are a few of the shading ideas used by 19th century engravers and lithographers.

ABCDEFGHIJKLMNOPQR
STUVWXYZ
abcdefghijklm
nopqrstuvwxyz

ABCDEFGHIJKLMNOPQRSTUVWXYZ
ABCDEFGHIJKLMNOPQRSTUVWXYZ

ABCDEFGHIJKLMN
OPQRSTUVWXYZ
abcdefghijklmnopqrs
tuvwxyz1234567890

Plate 83. A basic type style, Egyptian—credited to Vincent Figgins, about 1815.

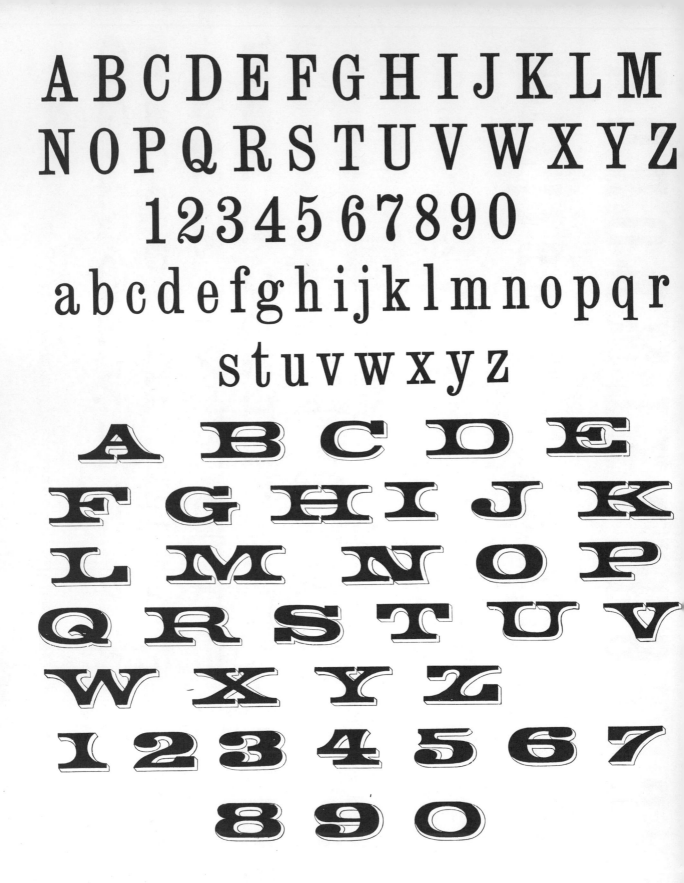

Plate 84. The Clarendons were developed in the 19th century—also a basic style.

Plate 85. A 19th century alphabet derived from an Italian 16th century style.

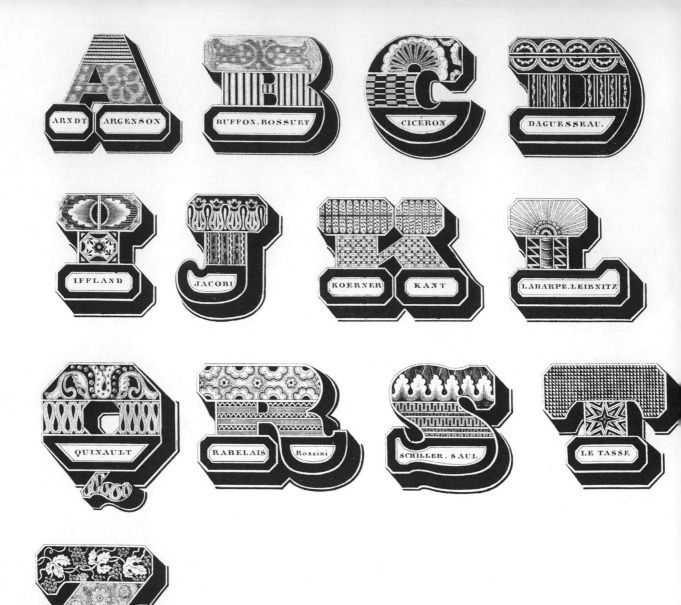

Plate 86. A 19th century design called *Lapidaire Monstre*—which it is, to say the least.

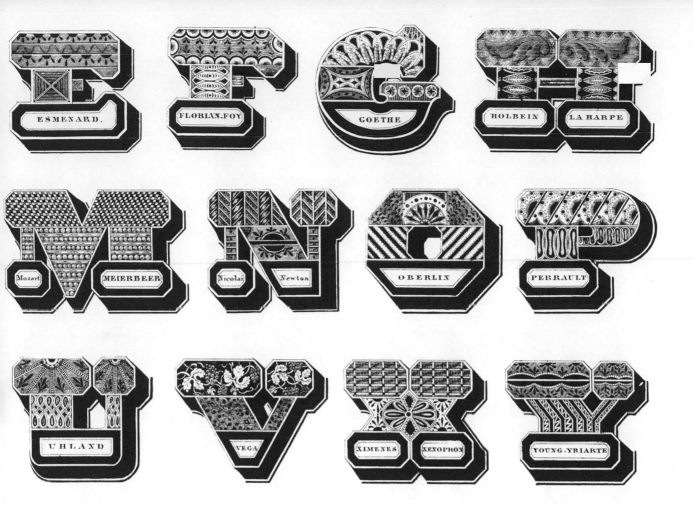

ALPHABET LAPIDAIRE MONSTRE.

ABCDEFGHI
KLMNOPQRS
TUVWXYZ

abcdefghijklmn
opqrstuvwxyz

ABCDEFGHIJKLMN
OPQRSTUVWXYZ

abcdefghiklmnopq|r|stuvw

xyz Rheingau Ladenburg Wein

1234567890 1234567890

Plate 87. Here are two Gothic alphabets with typical 19th century aberrations and trimmings.

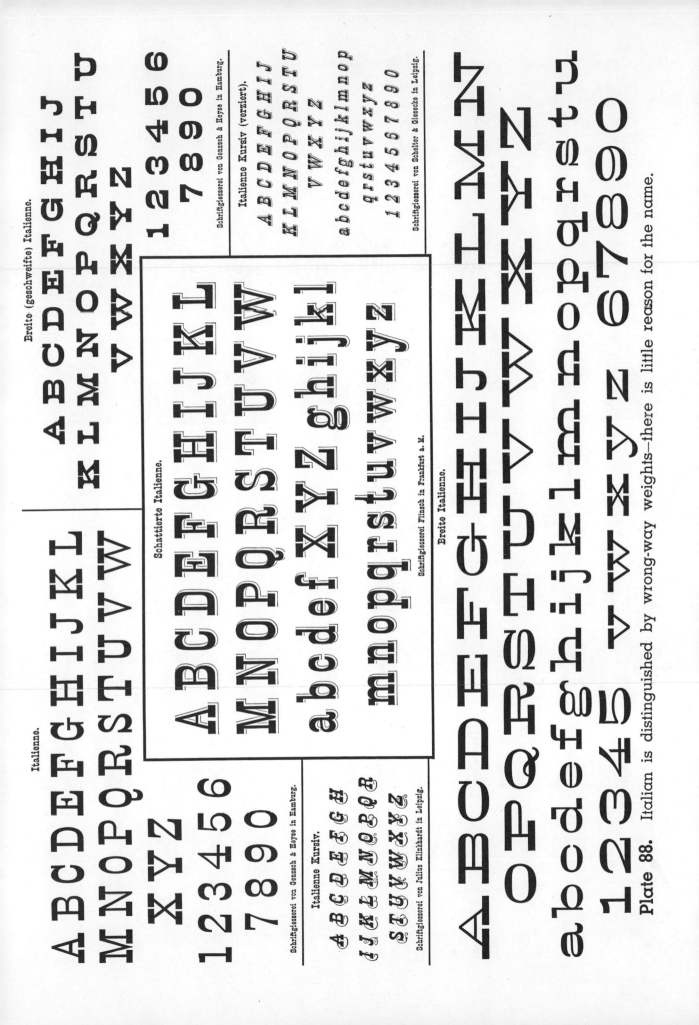

Plate 88. Italian is distinguished by wrong-way weights—there is little reason for the name.

Scroll Alphabet

Rustic Alphabet

Plate 89. Shrubbery of all kinds was used for initials during the last part of the 19th century.

Plate 90. These two-color initials cost 60¢ apiece in 1890—with the filigree border $1.00.

Plate 91. Gothic revival of the 1880's, with non-Gothic doodling as a background.

A B C D E F G H I J
K L M N O P Q R S T
U V W X Y Z
a b c d e f g h i j k l m n o p
q r s f t u v w x y z?
1 2 3 4 5 Arie 6 7 8 9 0

A B C D E F G H I J K
L M N O P Q R S T U V W
Schweiz W X Y Z Donau
a b c d e f g h i j k l m n o p q r
ß f t u b w x y z
Mainz König Bern

Plate 92. 19th century varieties of Dutch, German, and decorated Gothics.

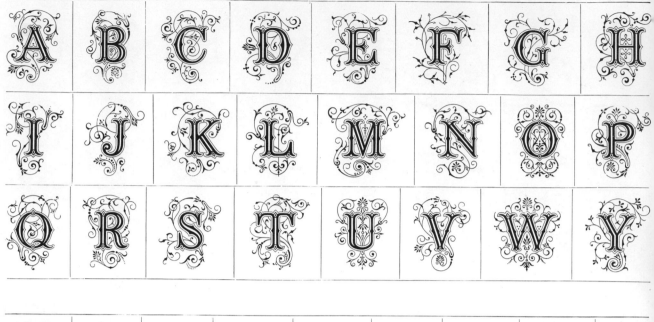

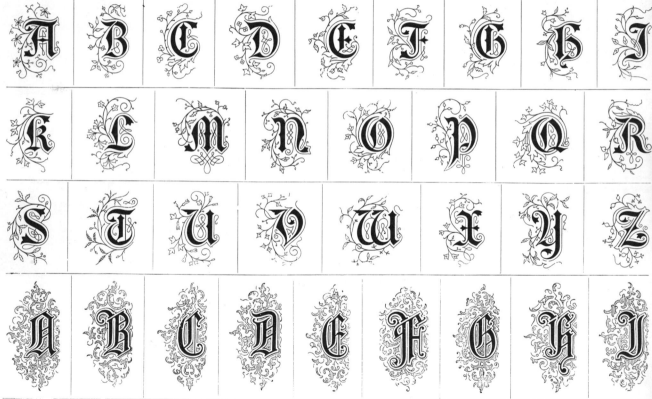

Plate 93. Arabesque designs appeared again in the 19th century—some were rather pretty.

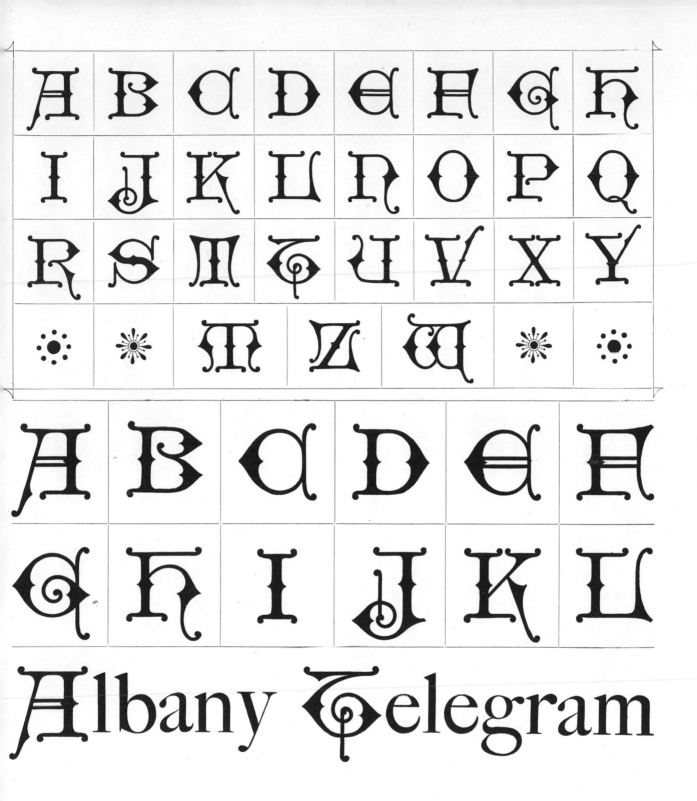

Plate 94. Gothic-revival designs based on the 14th century "closed-letter" design—1890.

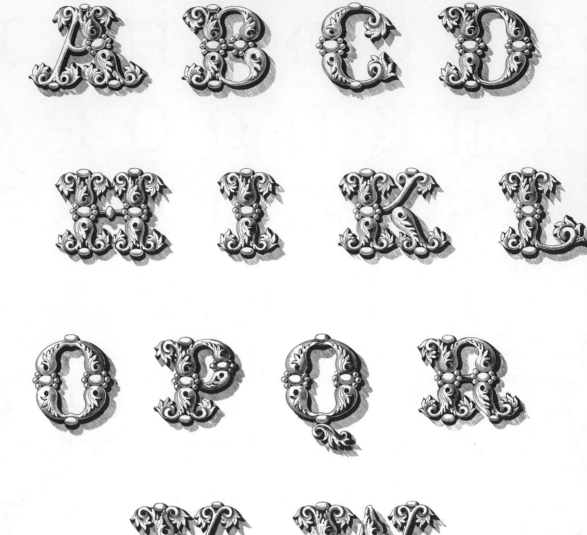

Plate 95. A leafy Tuscan from the Silvestre alphabet album, 1843-1844.

Plate 96. Shadowed and decorated—also from the Silvestre album—Paris.

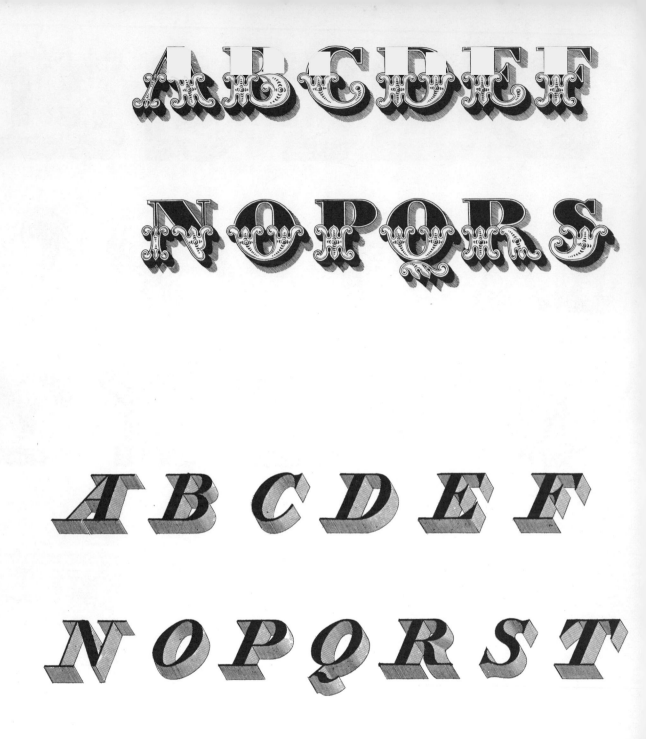

Plate 97. Half-and-half letters and perspective effects—typical 19th century malpractice.

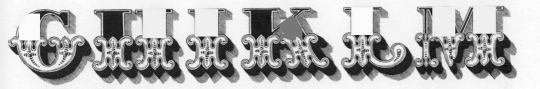

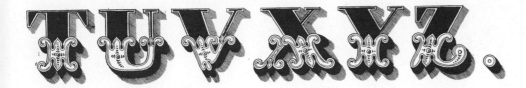

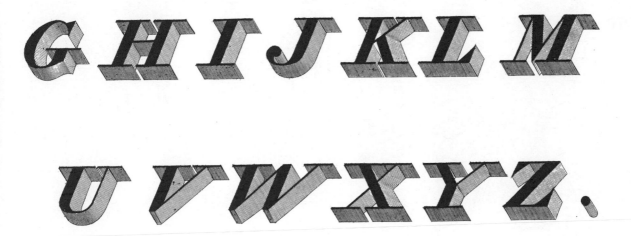

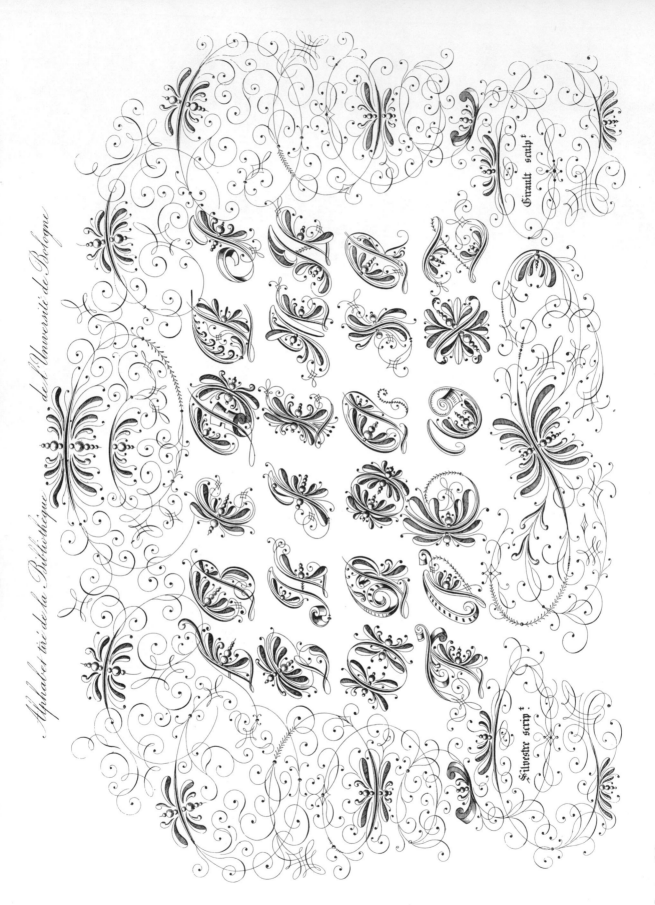

Alphabet tiré de la Bibliothèque de l'Université de Bologne

Girault script.

Silvestre script.

Plate 98. A sort of butterfly script that Silvestre picked out of the library at Bologna.

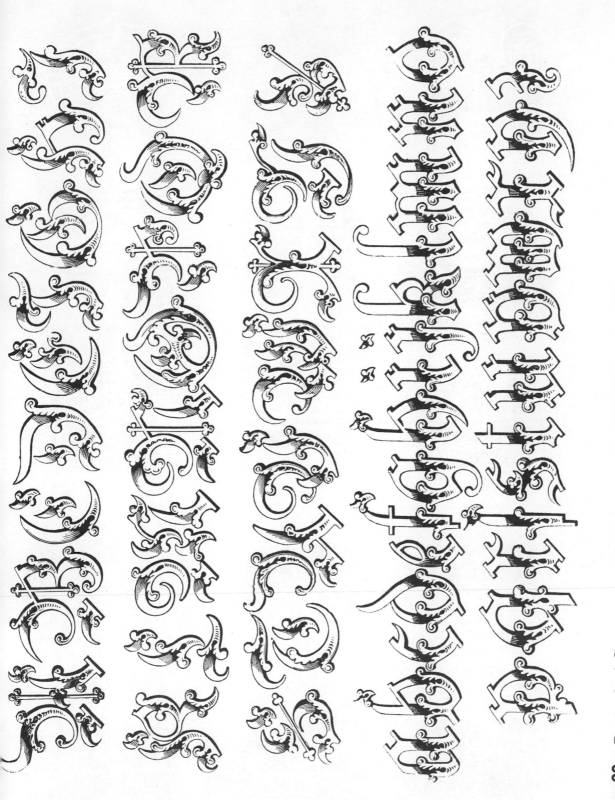

Plate 99. Revival of German baroque letters, but with Victorian styling—1859.

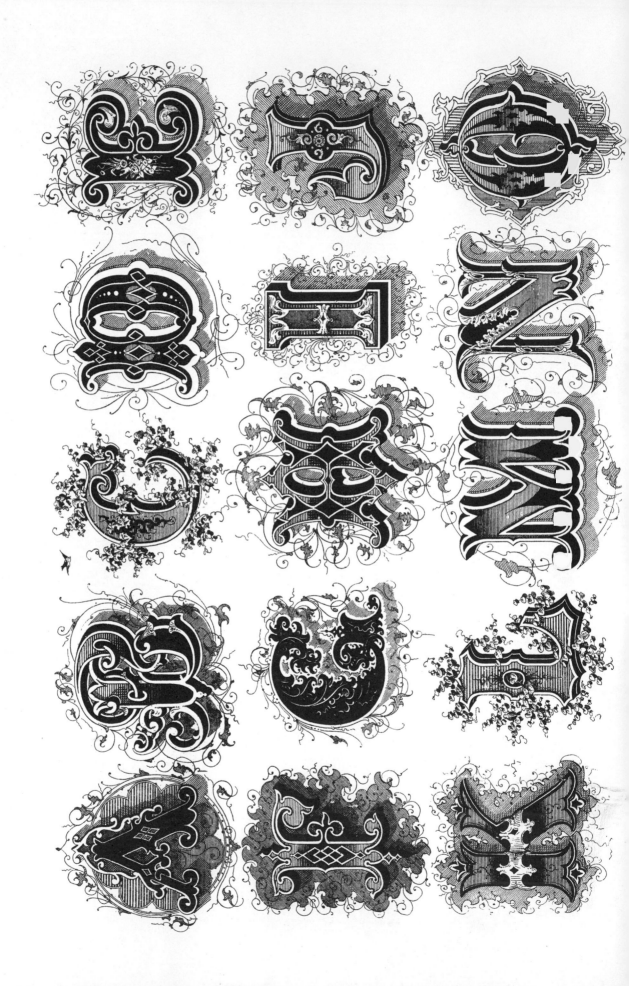

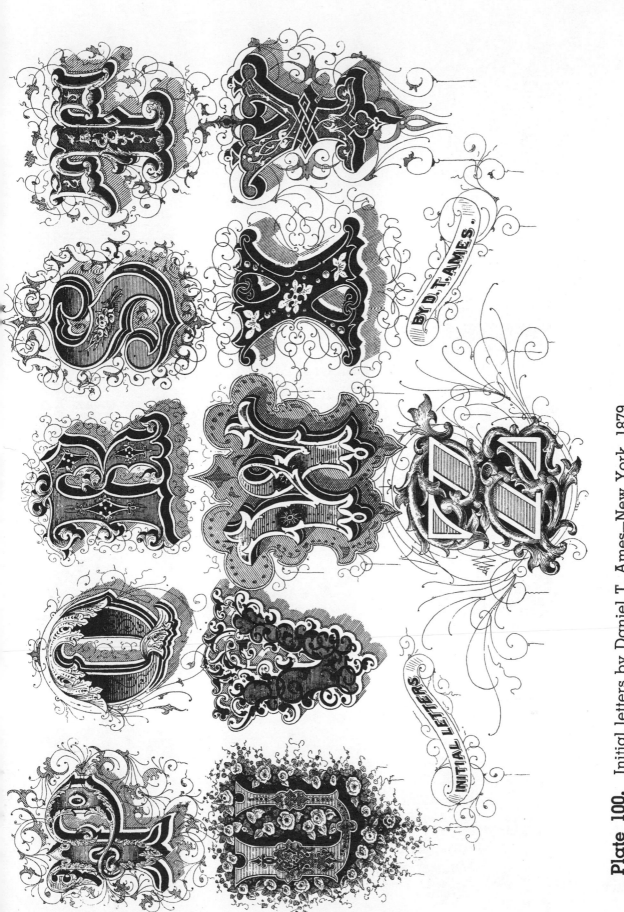

BY D. T. AMES.

INITIAL LETTERS

Plate 100. Initial letters by Daniel T. Ames—New York, 1879.

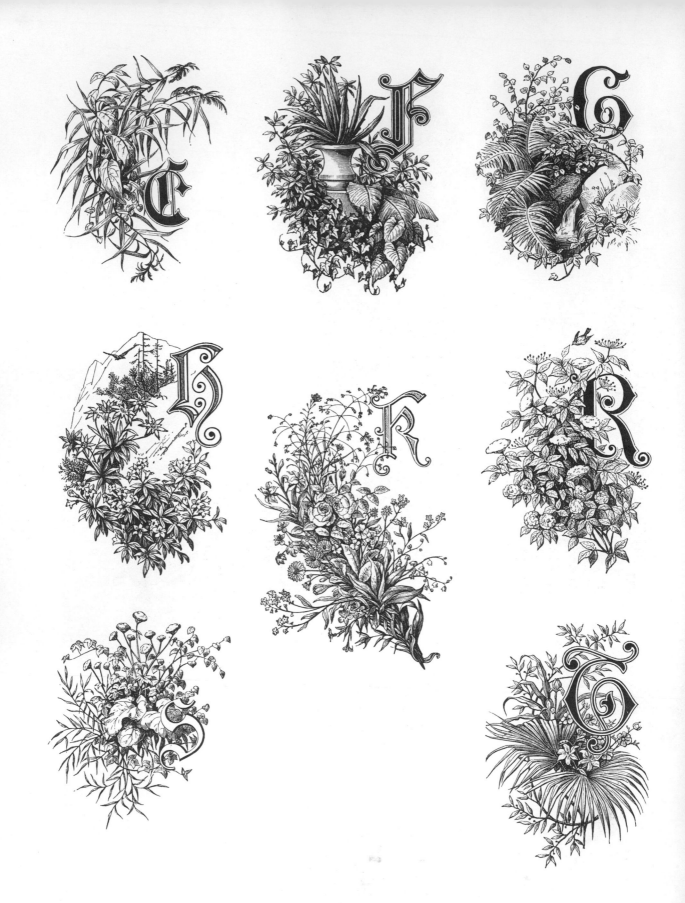

Plate 101. Plant initials were a cheerful conceit of the 1880's.

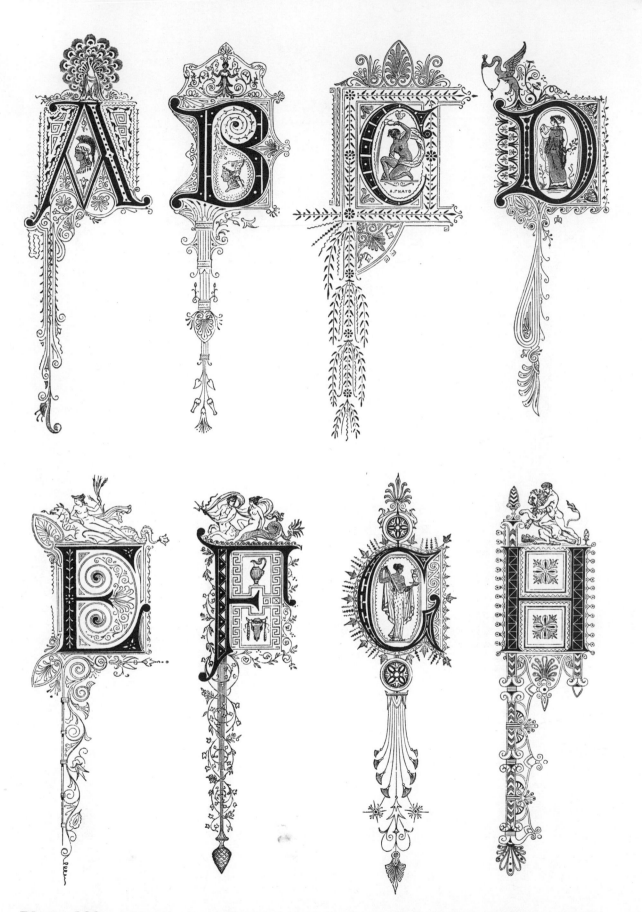

Plate 102. These were called "initials in the antique style"—really, style of 1889.

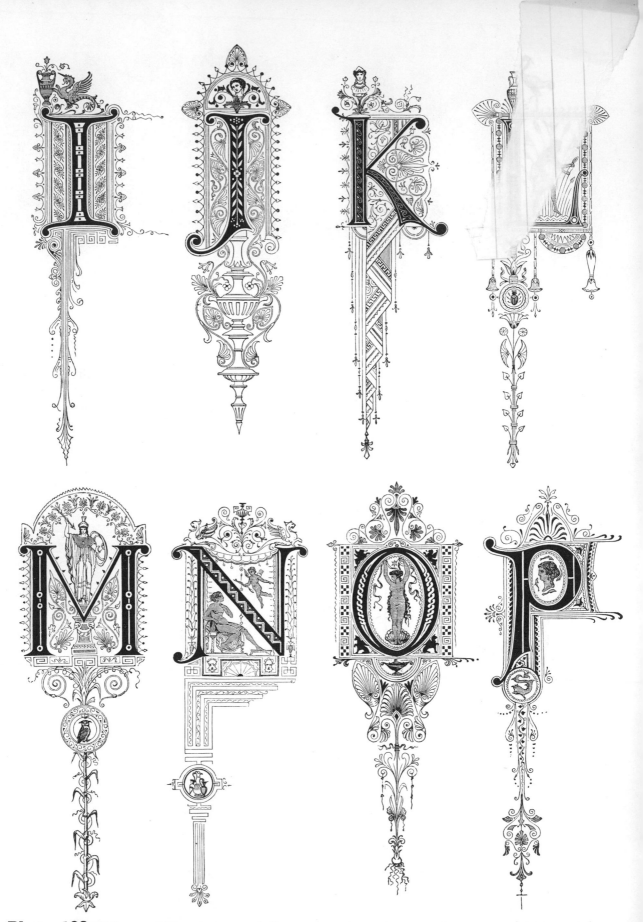

Plate 102. More of "antique style"—a clever confusion of all sorts of styles.
Continued

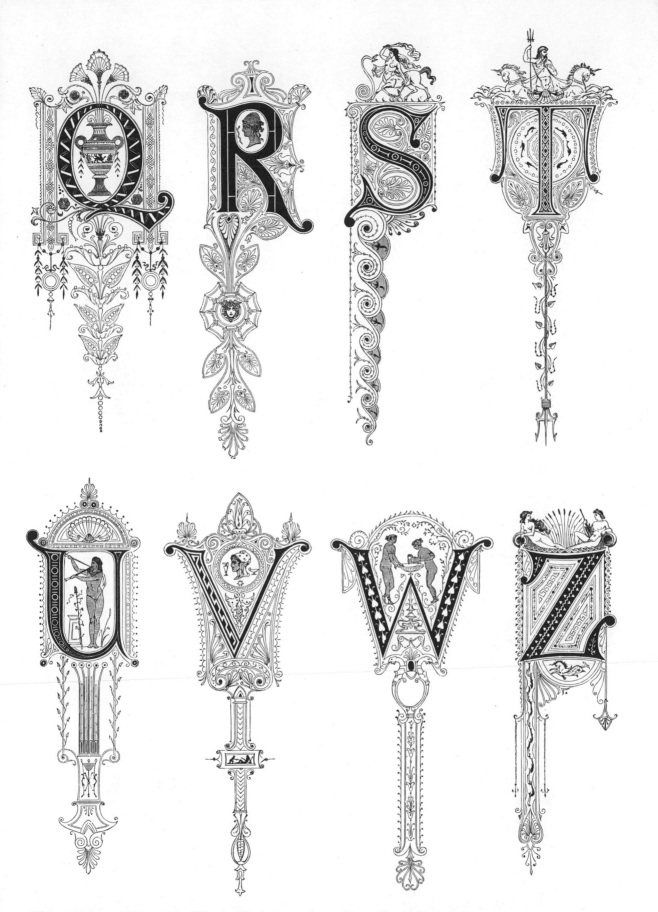

These were typographic initials produced in Germany—Americans imported them.

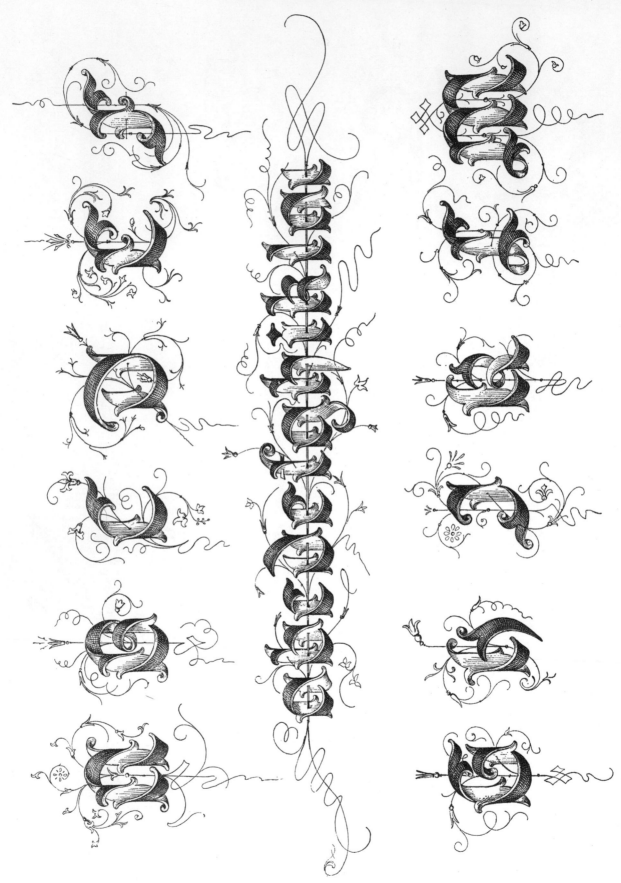

Somebody liked this kind of ribbon-letter in the 1880's.

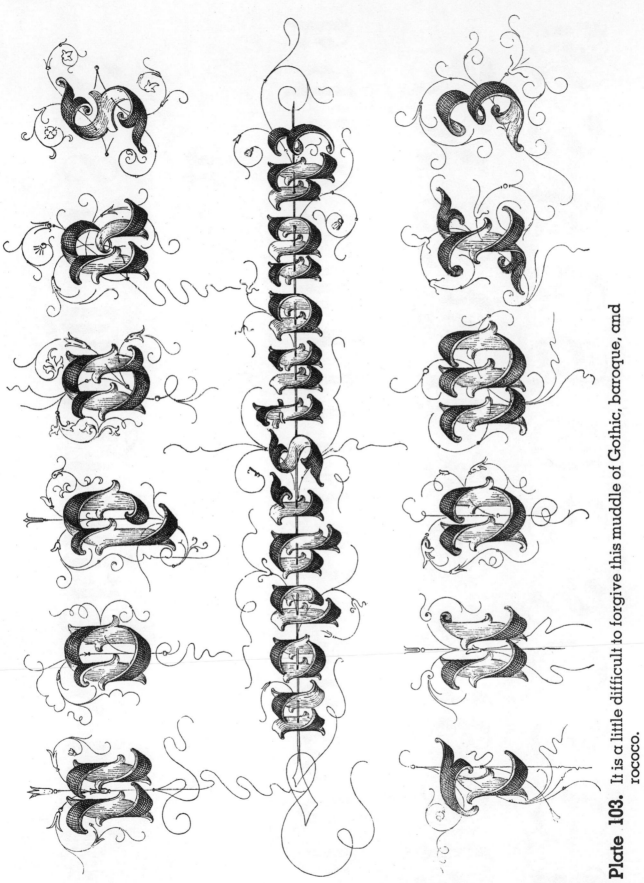

Plate 103. It is a little difficult to forgive this muddle of Gothic, baroque, and rococo.

abcdefghijklmnopqrstuvwxyzßfifl

1234567890 Erinnerung

Plate 104. The Munich Renaissance revived early Fraktur designs—Genzsch & Heyse foundry.

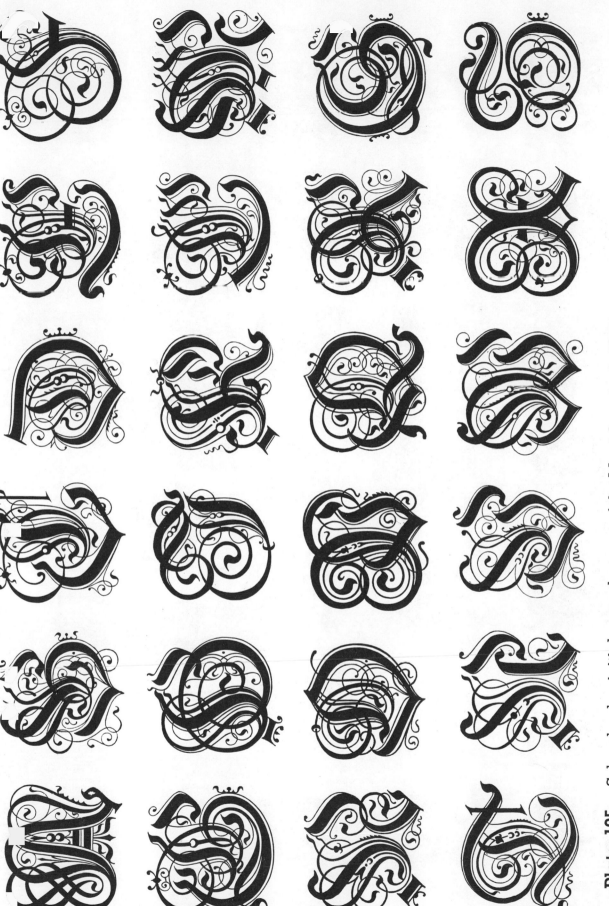

Plate 105. Schwabacher initials—another part of the Munich revival—1880's.

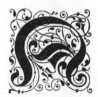 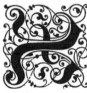

 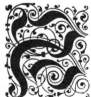

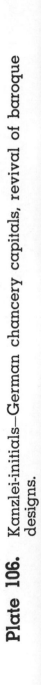

Plate 106. Kanzlei-initials—German chancery capitals, revival of baroque designs.

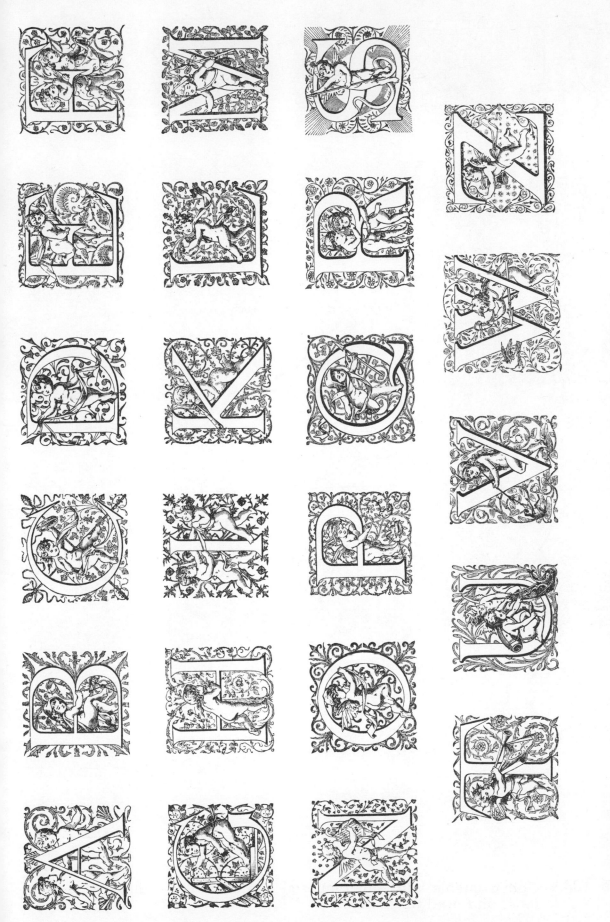

Plate 107. Called Renaissance initials—a poor imitation of early children's designs, 1880's.

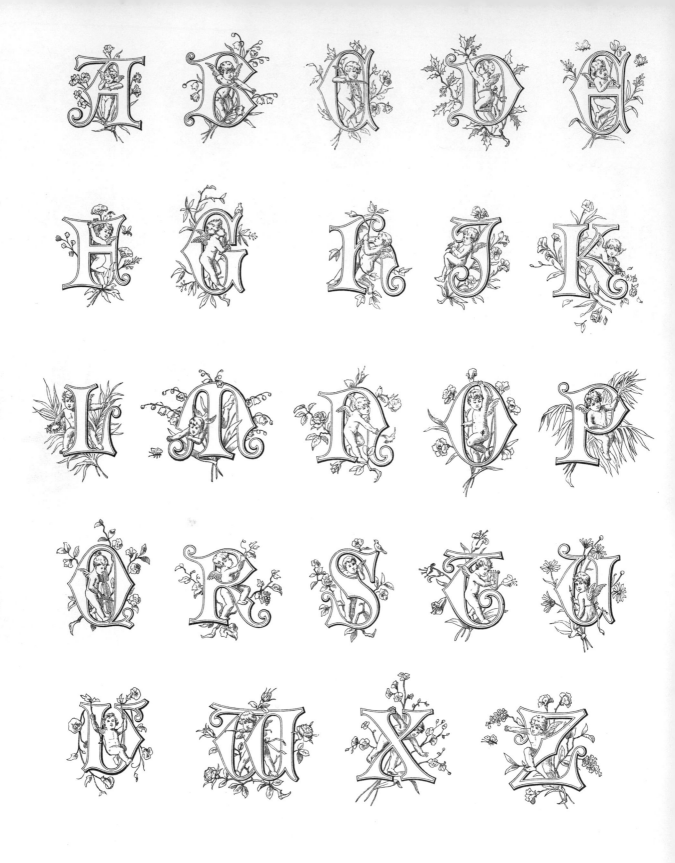

Plate 108. Gothic initials with superimposed sentimentality—called Amorette, and used about 1889.

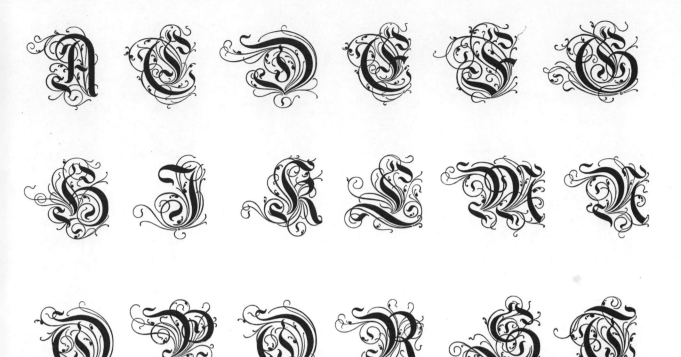

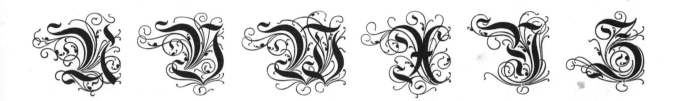

Plate 109. Revival of a Gothic chancery letter—related to the Fraktur design—German, 1880's.

Ornamental

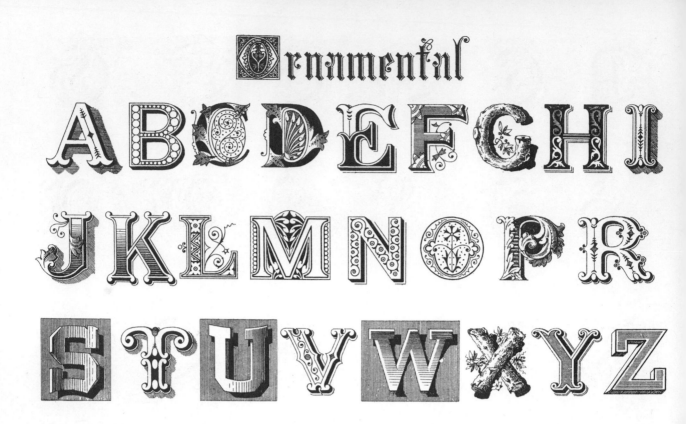

LETTERS VARIOUSLY SHADED

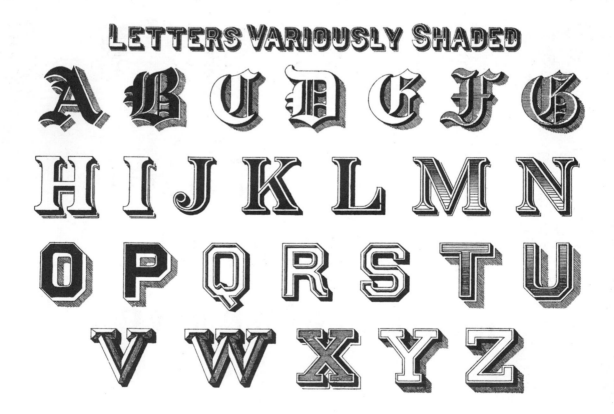

Plate 110. What the up-to-date draftsman copied in the 1880's.

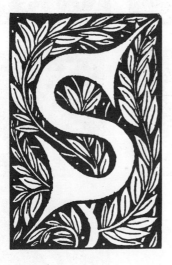
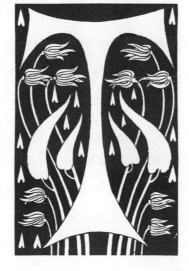
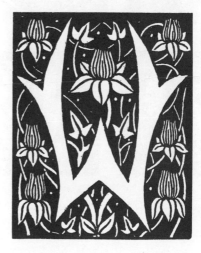

Plate 111. Aubrey Beardsley's attempt to avoid copying earlier designs—from *Morte d'Arthur*, 1893.

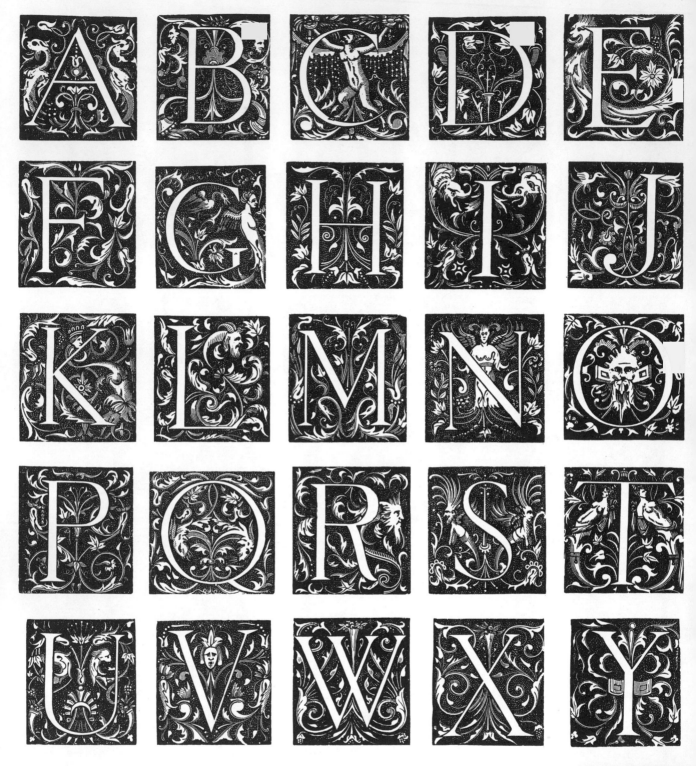

Plate 112. A set of initials used in England about 1880—possibly of French origin, cut in wood.

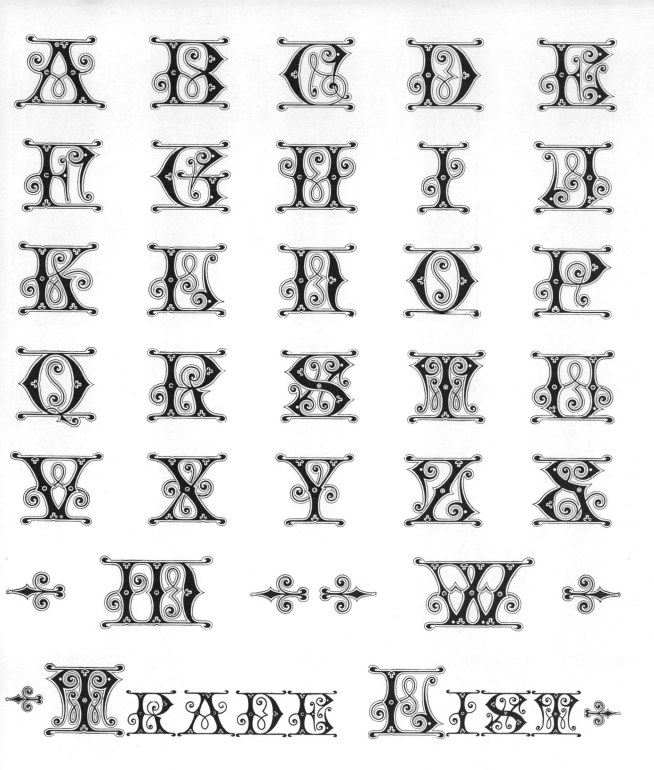

Plate 113. These initials were called Medieval, but they are really Victorian gingerbread, 1890.

Plate 114. A revival design—used by the Chiswick Press in England, middle of the 19th century.

Plate 115. A rather original alphabet used by the Chiswick Press—based on Gothic initials.

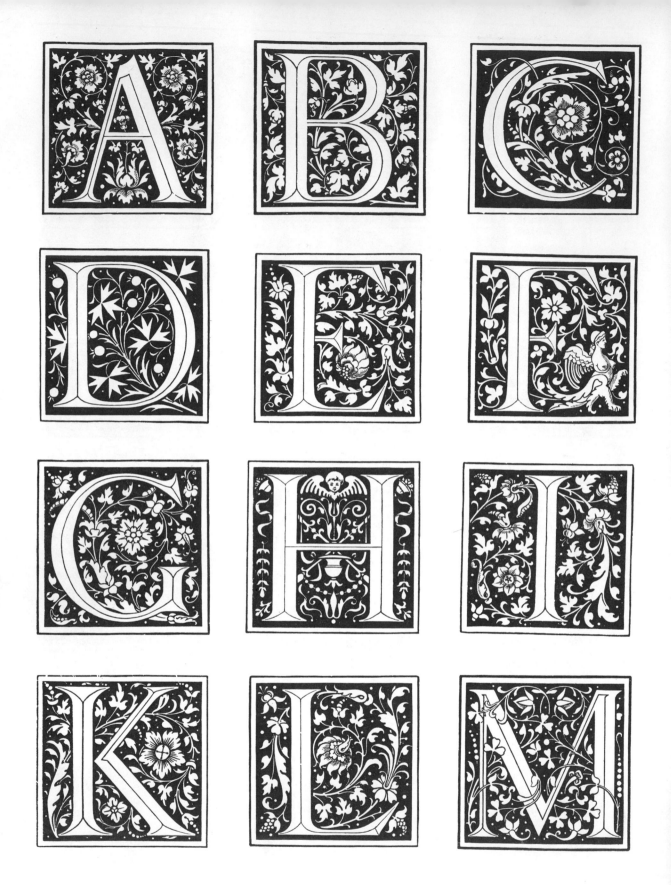

Plate 116. Rather fine late-19th century revival of Florentine Renaissance initials—Germany.

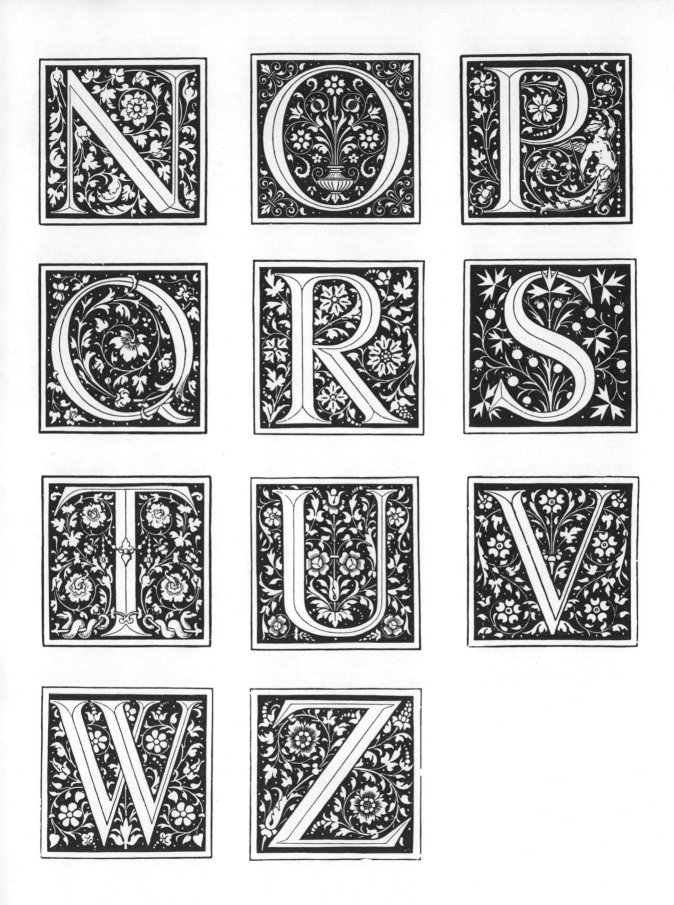

Second half of Florentine alphabet—color and texture a bit uneven (note the S).

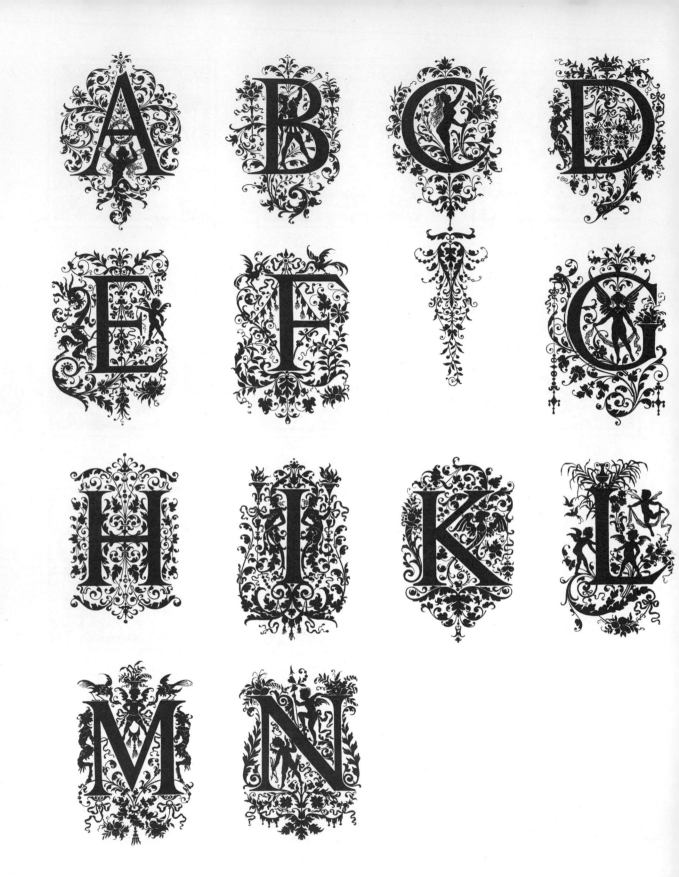

Plate 117. In 1889 the silhouette was a popular form of art—therefore one needed such initials.

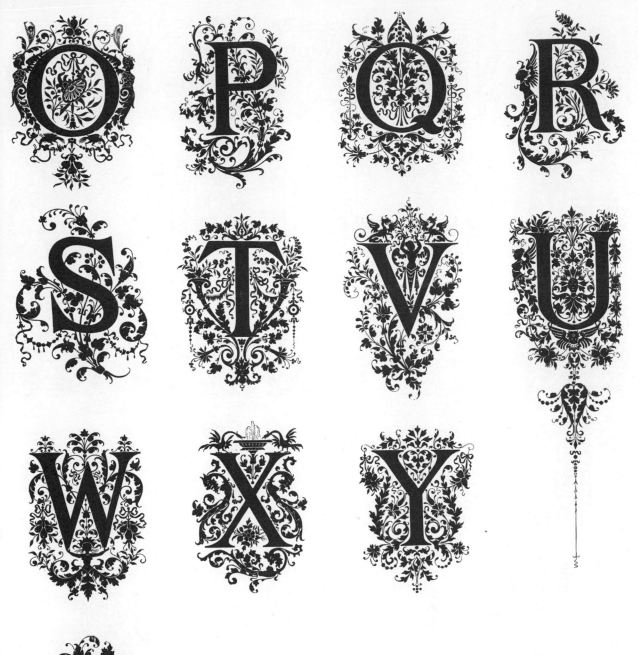

More silhouette initials—they are essentially a variety of the arabesque.

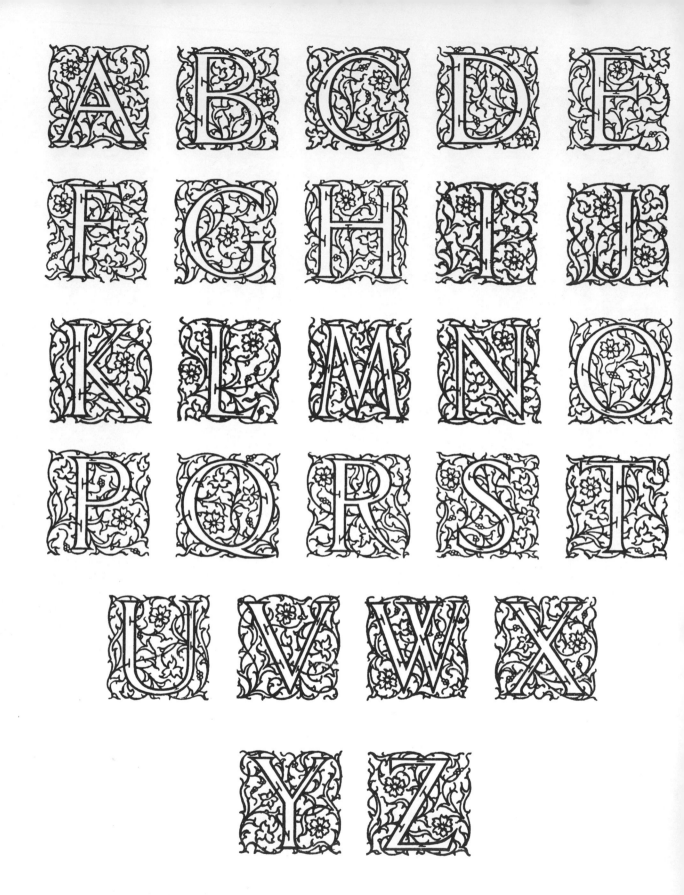

Plate 118. English revival of the arabesque design dating from about 1900.

 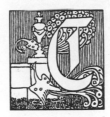

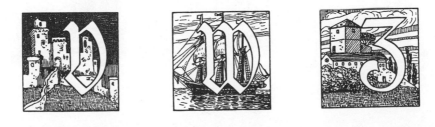

Plate 119. A Jugendstil alphabet produced in Germany in the early 1900's.

Plate 120. Initials engraved on wood by Edward Wadsworth—England, 1920.

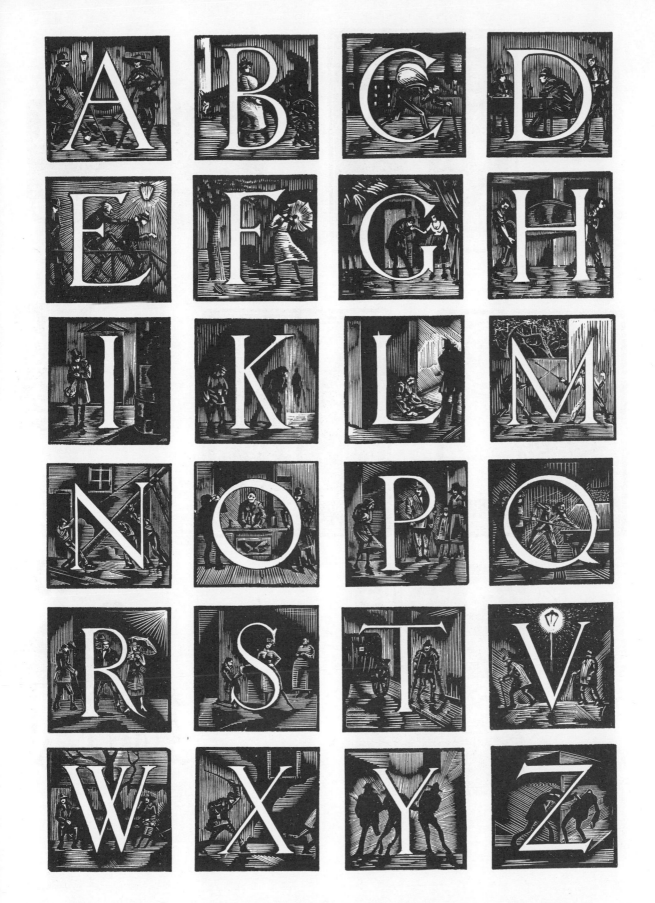

Plate 121. A set of wood-engraved initials—the terrors of night life, Riga, Latvia, 1924.

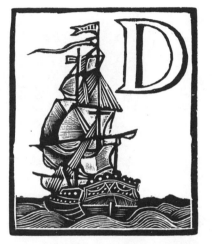
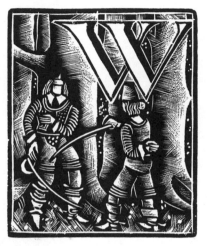

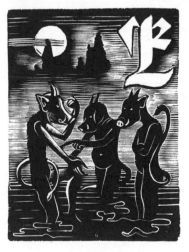

Plate 122. Wood engravings by Karl Rossing—Germany, 1923.

Plate 123. Initial designs by Curt Reibetanz—Germany, 1925.

Bibliography

ALPHABET ALBUM, Collection de soixante feuilles d'alphabets histories et fleuronnes, by J. B. Silvestre, Paris 1843-1844.

ALPHABETS A manual of lettering for the use of students, with historical and practical descriptions, by Edward F. Strange, George Bell and Sons, London 1898.

ALPHABETS, MONOGRAMS, INITIALS, published by E. W. Bullinger, Co. 1887.

ALPHABETS OLD AND NEW For the use of craftsmen, with an introductory essay on the "Art of the Alphabet," by Lewis F. Day, B. T. Batsford Ltd., London; Charles Scribner's Sons, New York, 1910.

AMES' ALPHABETS adapted to the use of architects, engravers, engineers, artists, sign painters, draughtsmen, by Danield T. Ames, published by William T. Comstock, New York 1879.

ARCHIV FUR BUCHGEWERBE UND GEBRAUCHSGRAPHIK, Heft 7, 1925—Heft 4, 1929.

THE BOOK OF KELLS, described by Sir Edward Sullivan, The Studio Ltd., London 1933.

THE BOOK OF KELLS, published with the authority of the Board of Trinity College, Dublin and with the cooperation of the Swiss National Library by Urs Graf Verlag, Berne 1950. Facsimile.

THE BOOK OF LINDISFARNE, published by Urs Graf Verlag, Berne 1957. Facsimile.

THE BOOK OF ORNAMENTAL ALPHABETS ANCIENT AND MODERN, from the eighth to the nineteenth century, collected and designed by F. Delamotte, E. and F. N. Spon, London 1859.

THE CANTERBURY SCHOOL OF ILLUMINATION, 1066-1200, by C. R. Dodwell, Lambeth Librarian, Cambridge at the University Press 1954.

CATALOGUE OF SPECIMENS OF PRINTING TYPES by English and Scottish Printers and Founders, 1665-1830, compiled by W. Turner Berry & A. F. Johnson, with an introduction by Stanley Morison, Oxford University Press; Humphrey Milford, London 1935.

COPLEY'S PLAIN AND ORNAMENTAL STANDARD ALPHABETS drawn and arranged by Frederick S. Copley, published by George E. Woodward, New York 1870.

THE DECORATED LETTER from the VIIIth to the XIIth century, by Emile-A. Van Moe. Editions du Chene, Paris 1950.

DECORATIVE INITIAL LETTERS Collected and arranged with an introduction by A. F. Johnson, The Cresset Press, London 1931.

DRAUGHTSMAN'S ALPHABETS a series of plain and ornamental alphabets, designed especially for engineers, architects, draughtsmen, engravers, painters, etc., by Hermann Esser, published by Keuffel and Esser Co., New York 1877.

EARLY WOODCUT INITIALS containing over thirteen hundred reproductions of ornamental letters of the fifteenth and sixteenth centuries, selected and annotated by Oscar Jennings, M.D., Methuen and Co., London 1908.

GASKELL'S GUIDE to writing, pen-flourishing, lettering, and letter writing, by G. A. Gaskell, New York 1883.

GESCHICHTE DER ABENDLANDISCHEN SCHREIBSCHRIFTFORMEN, by Hermann Delitsch, Karl W. Hiersemann, Leipzig 1928.

GRAMMATOGRAPHIE DU IXᵉ SIECLE, tipes calligraphiques tires de la Bible de Charles-le-Chauve, by J. B. J. Jorand, Paris 1837.

THE HANDBOOK OF MEDIAEVAL ALPHABETS AND DEVICES, by Henry Shaw, published by Bernard Quaritch, London 1853.

ILLUMINATION and its development in the present day, by Sidney Farnsworth, George H. Doran Company.

DAS INITIAL Phantasie und Buchstabenmalerei des frühen Mittelalters, by Alois Schardt, Rembrandt-Verlag, Berlin 1938.

INITIALEN, ALPHABETE UND RANDLEISTEN VERSCHIEDENER KUNSTEPOCHEN, a portfolio compiled by Carl Hrachowina, published by Carl Graeser, Vienna 1897.

LESSONS IN THE ART OF ILLUMINATING by W. J. Loftie, Blackie & Son, London.

LETTERING The history and technique of lettering as design, by Alexander Nesbitt, Prentice-Hall, New York 1950. New edition: THE HISTORY AND TECHNIQUE OF LETTERING, Dover Publications, New York 1957.

NINETEENTH CENTURY ORNAMENTED TYPES AND TITLE PAGES, by Nicolette Gray, Faber & Faber Ltd., London 1938.

OEUVRES DE JEAN MIDOLLE, published by Emile Simon Fils, Strasbourg 1834-1835-1836.

PRANG'S STANDARD ALPHABETS, L. Prang & Co., 1891.

ROMAN LETTERING A study of the letters of the inscriptions at the base of the Trajan column, with an outline of the history of lettering in Britain, by L. C. Evetts, A. R. C. A., Pitman Publishing Corporation, New York-Chicago 1938.

ROMANISCHE ZIERBUCHSTABEN UND IHRE VORLAUFER, by Karl Löffler, Verlag Hugo Matthaes, Stuttgart 1927.

DER ST. GALLER FOLCHART-PSALTER eine Initialstudie, by Franz Landsberger, Verlag der Fehr'schen Buchhandlung, St. Gallen 1912.

DIE SCHRIFT Atlas der Schriftformen des Abendlandes vom Altertum bis zum Ausgang des 18. Jahrhunderts, by Hermann Degering, Verlag von Ernst Wasmuth, Berlin 1929. There are English and French editions of this work.

SCHRIFTEN ATLAS, a collection made by Ludwig Petzendorfer, Verlag von Julius Hoffmann, Stuttgart 1889.

SPECIMENS OF ELECTROTYPES, A. Zeese & Co., 1891.

THE TRAJAN CAPITALS The capitals from the Trajan column at Rome, by Frederic W. Goudy, Oxford University Press, New York 1936.

Sources of Plates

The material in this book was compiled from works listed in the bibliography. This index indicates to the reader the source of each of the plates; it is a simple compilation of the books or portfolios listed in the bibliography followed by the plate numbers. The arrangement follows the order of the bibliography.

ALPHABET ALBUM, by J. B. Silvestre: Plates 20, 95, 96, 97, 99, and bottom of 8.

ALPHABETS, by Edward F. Strange: Plate 15.

ALPHABETS, MONOGRAMS, INITIALS, published by E. W. Bullinger: Plates 5, 6, 14, top of 18, 28, 103.

ALPHABETS OLD AND NEW, by Lewis F. Day: Plates 24 and 29.

AMES' ALPHABETS, by Daniel T. Ames: Plate 100.

ARCHIV FUR BUCHGEWERBE UND GEBRAUCHSGRAPHIK, Heft 7, 1925: Plate 123—Heft 4, 1929: Plate 122.

THE BOOK OF ORNAMENTAL ALPHABETS ANCIENT AND MODERN, by F. Delamotte: Plate 99, and top of 8, bottom of 18, top of 81.

COPLEY'S PLAIN AND ORNAMENTAL STANDARD ALPHABETS, by Frederick S. Copley: Plates 80 and 82.

DECORATIVE INITIAL LETTERS, by A. F. Johnson: Plates 31, 35, 36, 40, 41, 42, 45, 46, 52, 55, 57, 58, 61, 62, 63, 65, 66, 67, 72, 73, 74, 75, 79, 111, 112, 114, 115, 118, 119, 120, 121.

DRAUGHTSMAN'S ALPHABETS, by Hermann Esser: Plates 110, and bottom of 81.

EARLY WOODCUT INITIALS, by Oscar Jennings, M.D.: Plates 37, 38, 39, 43, recto 44, 53.

GASKELL'S GUIDE, by G. A. Gaskell: Plate 32.

GRAMMATOGRAPHIE DU IXᵉ SIECLE, by J. B. J. Jorand: Plates 2 and 3.

THE HANDBOOK OF MEDIAEVAL ALPHABETS AND DEVICES, by Henry Shaw: Plates 12, 13, 16, 17, 19, 21, 22, 25, 26, 27, 30, 34, 47, 48, 49, 50, 51.

INITIALEN, ALPHABETE UND RANDLEISTEN VERSCHIEDENER KUNSTEPOCHEN, by Carl Hrachowina: Plates 7, 10, 11, verso 44, 54, 56, 59, 60, 64, 70, 71, 77, 78.

LESSONS IN THE ART OF ILLUMINATING, by W. J. Loftie: Plates 1 and 23.

OEUVRES DE JEAN MIDOLLE: Plates 85 and 86.

PRANG'S STANDARD ALPHABETS, L. Prang & Co.: Plate 89.

SCHRIFTEN ATLAS: Plates 4, 9, 68, 69, 76, 83, 84, 87, 88, 91, 92, 101, 102, 104, 105, 106, 107, 108, 109, 116, 117.

SPECIMENS OF ELECTROTYPES, A. Zeese & Co.: Plates 90, 93, 94, 113.